所作

S H O S A

Meditations in Japanese handwork

Ringo Gomez — Rob Walbers

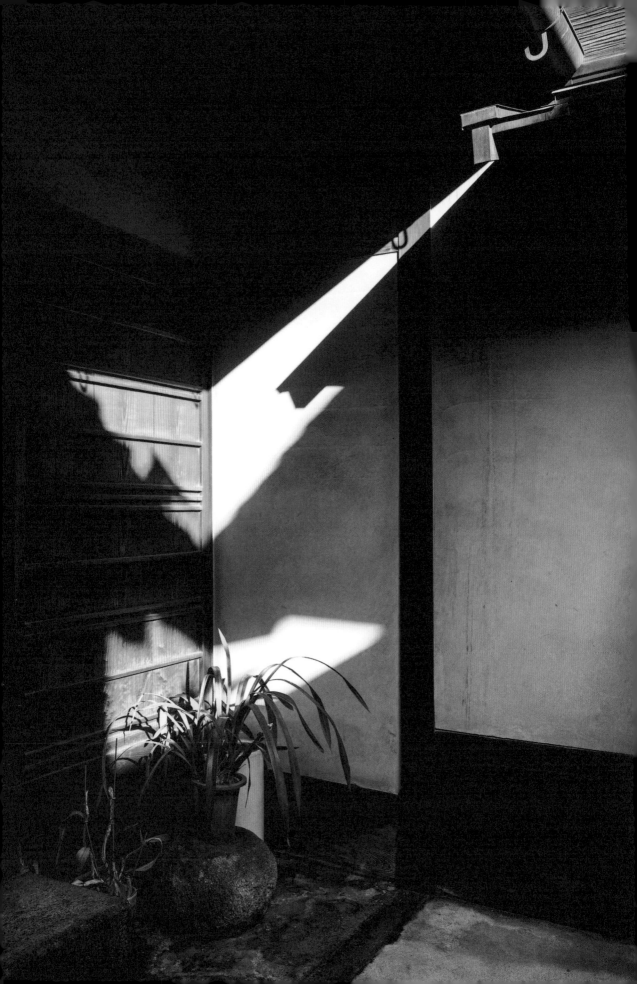

所作

The first time I heard about *shosa* was when I was talking to Tomohiro Kishida in his tiny studio in Osaka. A young weaver, he was on a quest to make everything from scratch. At some stage during our conversation, he mentioned that the process of weaving was just as important to him as the final product. The simple, repetitive movements of weaving induced a trance-like state in him, comparable to meditation. He also mentioned that the Japanese have a word for it, namely shosa.

The word stuck with me. As a design journalist, I had had similar conversations in Europe with craftsmen and designers as they tried to explain the beauty of making, the purity of simple hand gestures, and being in the moment. But they did not have a word for it.

One day, I was sitting in a trendy coffee bar in Paris with my friend Takaharu Saito. As the owner/founder of a communication agency in Japan, he travels the world, promoting the Japanese crafts he so deeply admires wherever he goes. When I mentioned that I was planning to write a book about shosa, he answered: "Um." Japanese people have a tendency to mull over their answer before replying, and Taka-san has mastered this art to perfection. "Have you tried Amazon?", he finally said and typed the Japanese characters 所作 on his tablet. A list of books for businessmen on how to behave appropriately flashed on his screen. "Shosa actually means behaviour", he added.

While I went to the counter to pay for our coffees, Taka-san waited outside. As I walked out, he made a formal bow and said, "gochisosama deshita" — thank you for the meal. It was all too polite for a guy I consider a friend. At first, I thought it was a form of etiquette. Come to think of it, it was more than that. It was good shosa.

Shosa is the easiest and, at the same time, the hardest of words to explain. Essentially, it boils down to a respectful and harmonious attitude and way of moving. Accordingly, good shosa refers to beautiful behaviour and movements. But this is not entirely right. Because shosa involves so much more than acting politely or in a prescribed way. This is what the Japanese call *saho* or etiquette. Shosa, meanwhile, implies a deeper intention, which means something different depending on who you are talking to. For some, it is about the beauty of a meticulous movement. Others mention mindfulness or moving while being in the moment. Some people talk about a pure heart that results in pure movements. Others point out that perfect shosa can only be achieved when the movement has been trained to become almost automatic and has become part of the body, resulting in perfectly natural poise. The Japanese tea ceremony is a perfect example.

日本

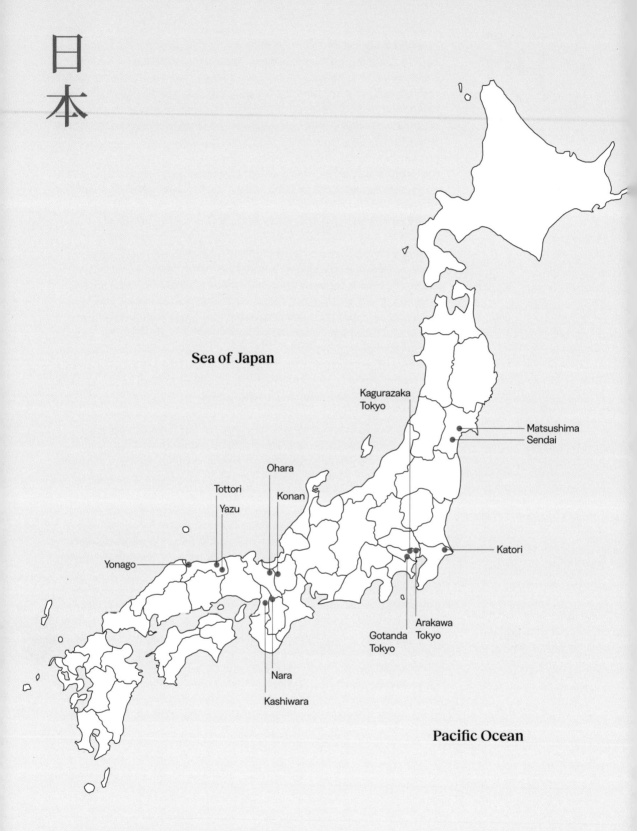

Sea of Japan

Kagurazaka
Tokyo

Matsushima
Sendai

Ohara

Tottori
Konan

Yazu

Yonago

Katori

Arakawa
Tokyo

Gotanda
Tokyo

Nara

Kashiwara

Pacific Ocean

I chose traditional Japanese crafts as my starting point. After all, who could have more to say about movement than a craftsman who uses his hands in a particular way? Gradually, however, I came to understand that the scope of shosa extends far beyond crafts, as the Amazon book list had already suggested. I learned that shosa is embedded in every aspect of Japanese society. In essence, it describes the deferential behaviour of the Japanese that overseas visitors are quick to notice but find difficult to put into words. In a nutshell, shosa might be the one concept that makes the Japanese so quintessentially Japanese. But why do they move in this streamlined, mannered and elegant way we find so striking?

Together with photographer Rob Walbers, a fellow Belgian who has lived in Tokyo for more than a decade, I travelled up and down the country in search of some answers. Shosa led us to different regions where we met various people. We visited a potter who still uses a three-hundred-year-old wood oven, a weaver who grows his own cotton and even an artist with a mental disability who painted allegories that had never been seen before. My intention was to tell the personal stories of these makers rather than just cutting to the chase and asking them about the meaning of shosa. Their attitude and movements are a consequence of their own journey, after all. Although most of the interviewees initially found it difficult to discuss shosa, my question struck a chord. Although shosa is not that widely used anymore, the word is still there, tucked away deep inside. And even though these makers may not use this word in their daily lives, they do still live by it.

This book is also an account of our travels as we roamed around one of the most poetic countries in search of an ungraspable form of purity.

Through twelve diverse interviews, I hope to offer some insights into a word that is just as important in Japan as it is in the rest of the world. Everybody feels shosa when they see it. However, only the Japanese have a word for it. I also want to stress that I never intended this book to be academic research. As such, it is, by necessity, incomplete. As a Western journalist, I am keenly aware that it is not my place to try to write an exhaustive dissertation on a word with such an ambiguous meaning. Perhaps this book is more of a window towards understanding shosa. Or, in keeping with the Japanese context, this book is merely the gate, not the temple.

Ringo Gomez

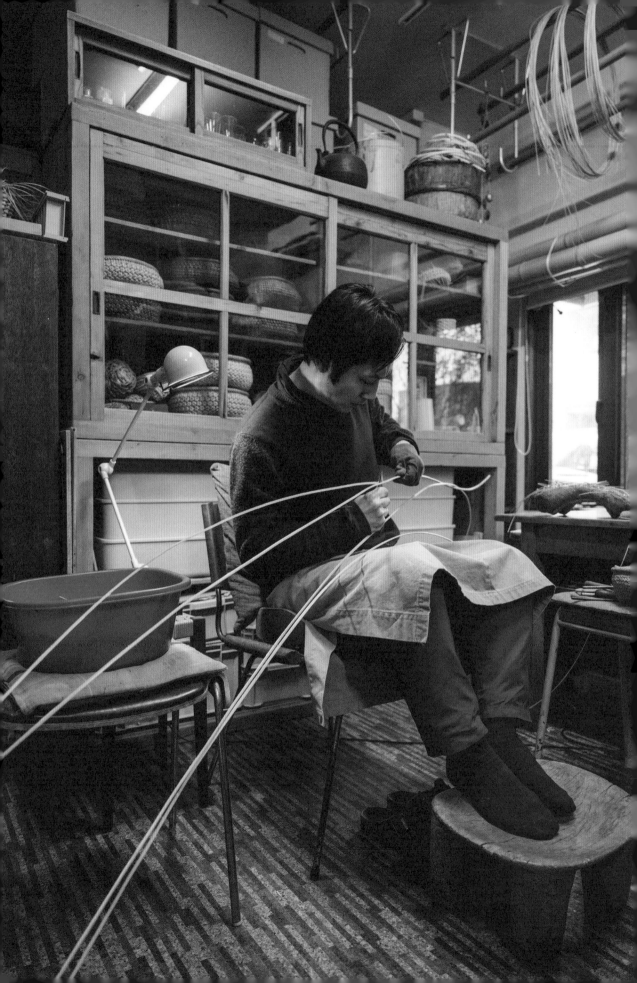

Beautiful behaviour

Junpei Kawaguchi
Basket weaver
Yonago

川
口
淳
平

My quest to grasp the meaning of shosa begins in the middle of nowhere, in a rural prefecture called Tottori. A prefecture is similar to a province. When I mention Tottori to fellow foreigners, it very rarely rings a bell. At most, people confuse it with Totoro, a famous anime creature from Studio Ghibli. Tottori is not very popular among the Japanese either. Located further to the west of Kyoto and nestled between the vast Chugoku mountains and the wild Sea of Japan, it is the least populous of all 47 prefectures of Japan (Tottori has a population of about 600,000, compared with Japan's population, which is estimated at 124 million). Western tourists rarely end up here, except perhaps to visit the prefecture's one gem in the outer east. The Tottori sand dunes are a Sahara-like, thirty-square-kilometre stretch, which is overrun by tourists in summer. Some sandboard off the dunes, others go on a camel ride even though camels are not native to the region. The name of Tottori has become somewhat synonymous with the dune. It is an impressive site, even on a stormy day, with just a handful of tourists struggling in the wind with their umbrellas.

Unfortunately for most tourists, the weather in Tottori is not remotely Saharan. The prefecture is situated in the San'in region, which loosely translates as the shadow side or the rainy side of the mountains. Hiroshima and the Seto Inland Sea, with its famous Naoshima art island, are located in San'yo, on the sunny side.

—

On a winter's day, the photographer and I drive through the rain to the far western point of the prefecture and the city of Yonago. Although Yonago looks like any other medium-sized Japanese city, with a checkerboard of neutral and nondescript low-rises that were seemingly all constructed in the eighties, Yonago has one peculiarity. A conic mountaintop peaks above the apartment buildings, cheap supermarkets and garages. Mount Daisen is Tottori's Fuji, rivalling its beauty although it is smaller, rising approximately 1,700 metres above sea level.

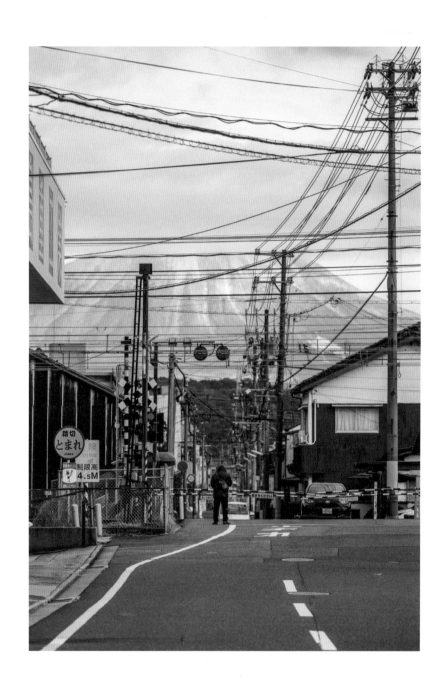

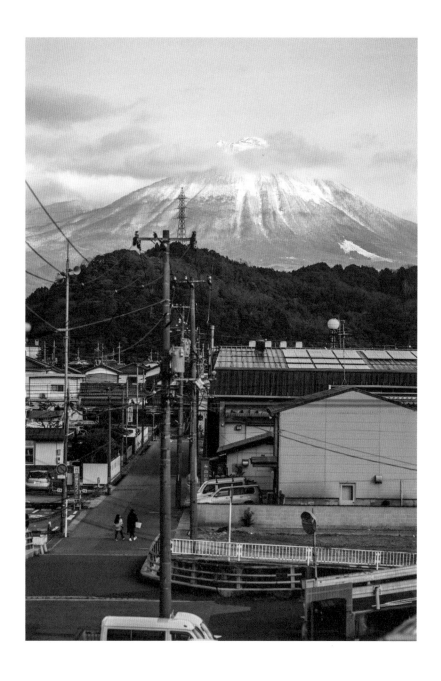

On the outskirts of Yonago, where a Western face is still considered the potential talk of the day, Junpei Kawaguchi's small workshop and store contrast with the rather gloomy conditions outside. A sense of calm and quiet reigns in the shop, which is somewhat reminiscent of a traditional Western pharmacy. Initially, the two cats observe us from the corner of their eyes but become more curious and approachable after a while. "The white one is sixteen years old", Junpei Kawaguchi says shily. "I have another at home that is 25 years old." Like me, he had no idea this was possible.

Kawaguchi's craft is called *hanamusubiami,* or flower (*hana*) knot (*musibi*) knitting (*ami*). For the past fifteen years, he has been creating rattan baskets with a characteristic flower-knot weave whose beauty is exceptionally subtle. The craft, which is unique to this region, originated in China and was originally used for vegetable baskets. In the Edo period (1603-1868), a prosperous and peaceful era of international isolation after many bloody battles between clans, Japanese craftsmen of the San'in region used rattan for high-end charcoal baskets.

"I started making leather bags about twenty-five years ago", Kawaguchi explains in his soothing voice. "Nobody in my family cares for crafts, and in junior high school, I preferred football. Gradually, I realised there are three levels of quality for soccer shoes based on the leather. The cheapest are synthetic, then there are cow leather ones, and the most expensive shoes are made of kangaroo leather. I tried all three, gradually switching to kangaroo leather shoes. The quality of these shoes inspired me to make shoes. Then leather bags... I don't get myself either", he laughs.

In 2009, Junpei met his future hanamusubiami sensei, Mister Nagasaki. "I wanted to add a rattan bag to my collection of leather goods and asked him to weave me one. But he refused, saying he had a severe backache."

Without Nagasaki sensei, there would be no hanamusubiami bag. The technique of flower-knot weaving is handed down according to the rule of *isshisoden* or sole succession: a father's trade secrets can only be passed to one person in the next generation. Nagasaki sensei did not want to burden a family member with a craft that did not offer them a living wage. Due to this economic reality, rattan as a craft has been all but wiped out in Japan. "The competition with rattan-producing countries in Southeast Asia, where the rattan palm plant grows, became unbearable", Kawaguchi explains. "Until I met Nagasaki sensei, I had never seen this Japanese craft. Even within the region, it is relatively unknown."

Kawaguchi became fascinated by the forgotten craft and persisted. "I started by asking Nagasaki sensei to teach me the basic skill of weaving, and not the secret flower-knot weaving technique. After four years, he decided to teach me this special skill." And that is how Kawaguchi became the eighth generation of the Nagasaki family.

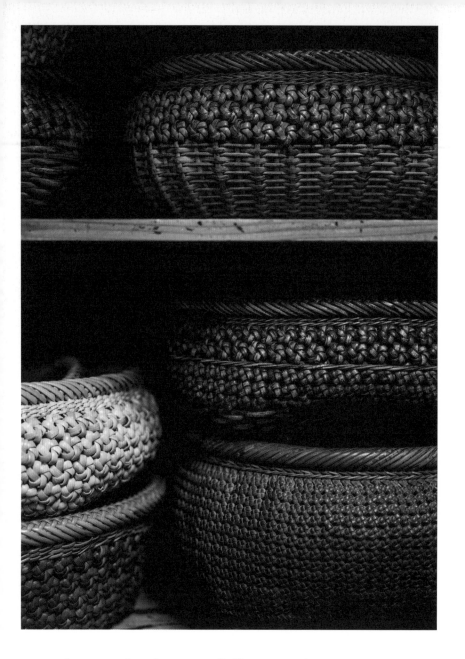

The technique of flower-knot weaving is handed down according to the rule of *isshisoden* or sole succession: a father's trade secrets can only be passed to one person in the next generation.

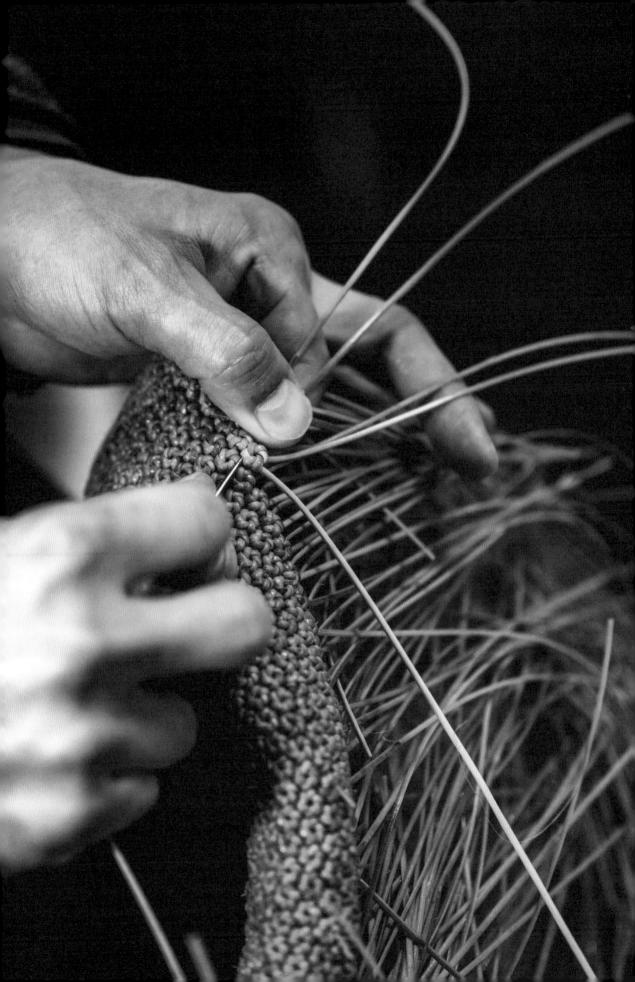

The special knot looks like a small flower with four to six petals. Every basket is partly woven with a plain weave and partly with the flower knot weave to enhance the beauty of the technique and add depth to the object. I notice that the shape of the baskets is quite peculiar, evoking a sense of asymmetry and fluidity as if shaped by the wind and water. Kawaguchi: "In Edo Japan, these baskets often had four paw-like protrusions at the bottom. This was done to distinguish the basket from a regular round-shaped and less expensive item. Even in those days, rattan was an expensive imported material, unlike bamboo, which also grows in Japan and is more routinely used for weaving." Apart from its strength and flexibility, rattan has a specific visual quality. Initially yellow, the material turns dark brown with age, which is why you should hold on to it for a longer period of time.

Kawaguchi places a rattan stick on the table. "Everything begins with preparation", he says as he gently cuts through the stick lengthwise, like butter, to create thin strips. When he notices my surprise at his ease of movement, he grins: "This is actually quite difficult for an untrained hand."

To demonstrate the knotting technique, he takes a half-finished basket, which he swiftly dips into a bucket of water to soften the rattan. He then sits down on a stool and begins to weave. His cats move closer. One hops onto a nearby shelf and the other drinks from a glass bowl behind him. The top of the basket resembles a chaotic mess of strips, but Kawaguchi's hands seem unbothered. "In the beginning, it was all about the beauty of the basket for me. Now, I enjoy the weaving", he says. "I do this for about fifteen hours a day. With less time, I wouldn't be able to finish them in time."

Weaving has taken over his life. It is a very slow process, taking up to five times longer because he uses rattan instead of bamboo. He produces about twelve baskets each year, some of which are quite small. "I guess I'm made for this movement", he says. "My sensei didn't like the special flower knot at all. He preferred the easier, plain weaving. But you have to like the movement." Watching Kawaguchi knot and weave is like watching a woodpecker peck holes into a tree: the wondrousness lies in the normalcy of the movement. "I guess I just keep on doing it."

I ask him the question that inspired this quest: what does shosa mean to you? Like most Japanese people, he takes his time to answer, as if savouring the question. "You know, people are inspired by the Japanese tea ceremony because it tells us to behave in a beautiful way, even while doing something as basic as drinking a cup of tea. We look up to people who behave calmly and nicely. This beautiful behaviour is what shosa means to me."

"You know, people are inspired by the Japanese tea ceremony because it tells us to behave in a beautiful way, even while doing something as basic as drinking a cup of tea. We look up to people who behave calmly and nicely. This beautiful behaviour is what shosa means to me."

For Kawaguchi, shosa is an attitude. It means being respectful to and mindful of the people and the objects that surround us. "It's about treating everything as if it's a very important item. If I were to throw these scissors onto the counter instead of laying them down calmly, it wouldn't be good for the scissors or for the counter, would it?"

"When you ask people about shosa, they will say all kinds of things," Kawaguchi adds. "In my opinion, people don't talk about having shosa. Instead, they care about whether someone has good or bad shosa. If I would throw around my tools and behave roughly, that would be considered bad shosa." Shosa is synonymous with respect for all of life. "I work with natural materials. As a craftsman, I take the life of plants. The least you can do is show respect for the life you've taken."

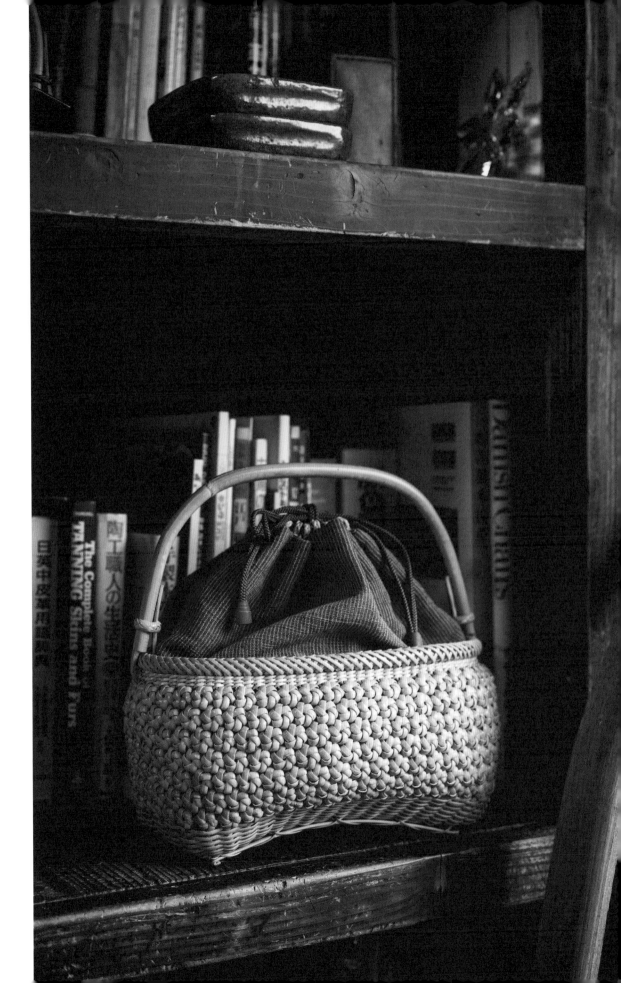

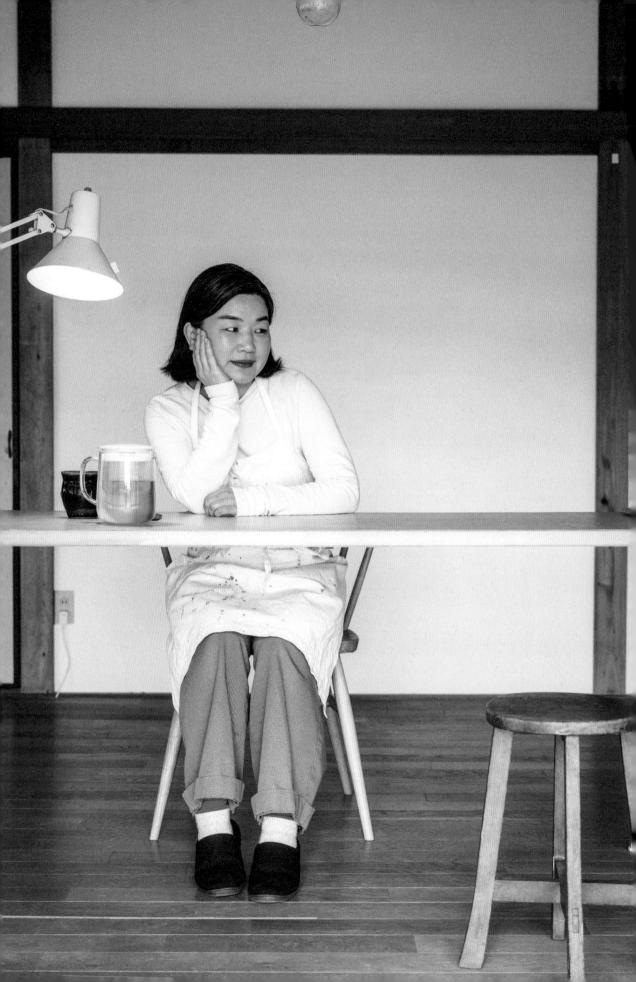

Minimalism in movement

Fumi Kawasaki
Hariko maker
and designer
Tottori

川崎富美

"The rice fields may look barren now, but soon they'll be filled with water and reflect the sky", Fumi Kawasaki tells me as she gazes at the fields. We are standing in the *engawa* at the front of her house, a traditional narrow porch closed off by sliding doors. Kawasaki takes a deep breath. After living in this large *kominka* or farmhouse all by herself in the middle of nowhere for over seven years, she still feels exhilarated even though the weather is not particularly good on the day I visit.

The countryside around Tottori plays a seminal role in Kawasaki's life. She was born and raised in this prefecture, more specifically in a traditional house on the other side of nearby Koyama Lake, which is close to Tottori City, the humble capital, and its famous sand dunes. At the age of eighteen, Fumi left to attend college and train as an industrial designer. Soon after graduating, she went to work for a Tokyo-based design office, where a new life awaited. She worked for this company for four years, which included a six-month stay in its Shanghai office.

After that, she changed jobs and went to work for Muji, a no-brand with a cult following. Its flagship store in Tokyo's Ginza district is like sacred ground for Japan enthusiasts, the result of a specific philosophy and aesthetic. Although a big retailer that sells household items and apparel, Muji offers a sanctuary for those seeking a minimalist style with functional and affordable tools for life. The name is short for *mujirushi ryohin*, which means 'no brand, good products'. From its inception in 1980, Muji offered a refreshing alternative to the logo mania of the eighties that swamped Japan and the world.

Almost all products are a neutral white or grey. Muji considers them empty recipients, waiting to be filled in depending on the user's needs. When you walk through a Muji store, none of the products clamour for your attention, nor will they do so in your living room. Instead, they are designed to blend in with the environment, leaving the user's mental space intact. Some were created by renowned designers such as Jasper Morrison, although no attribution is given. Everything is just Muji.

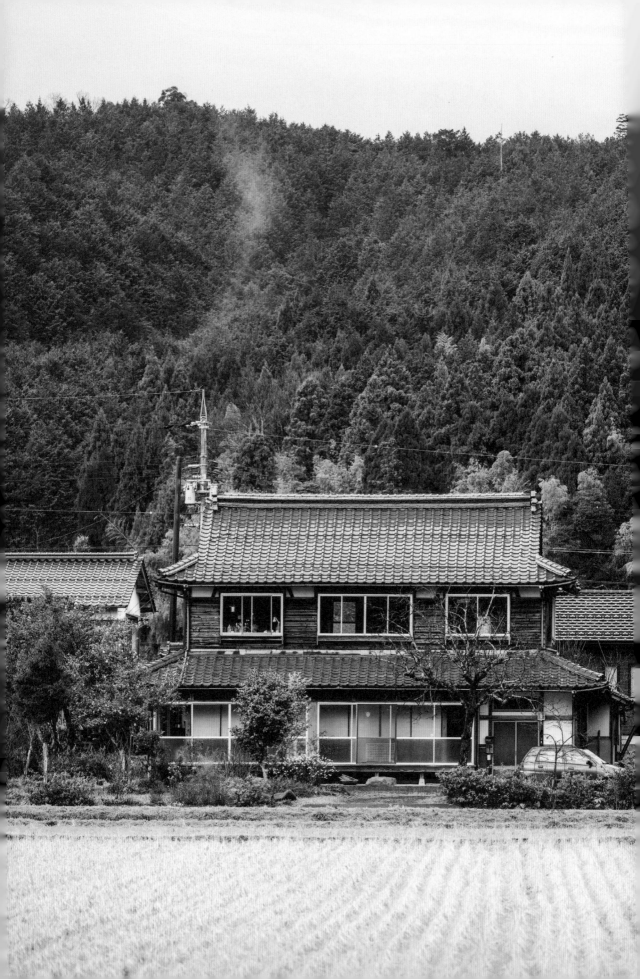

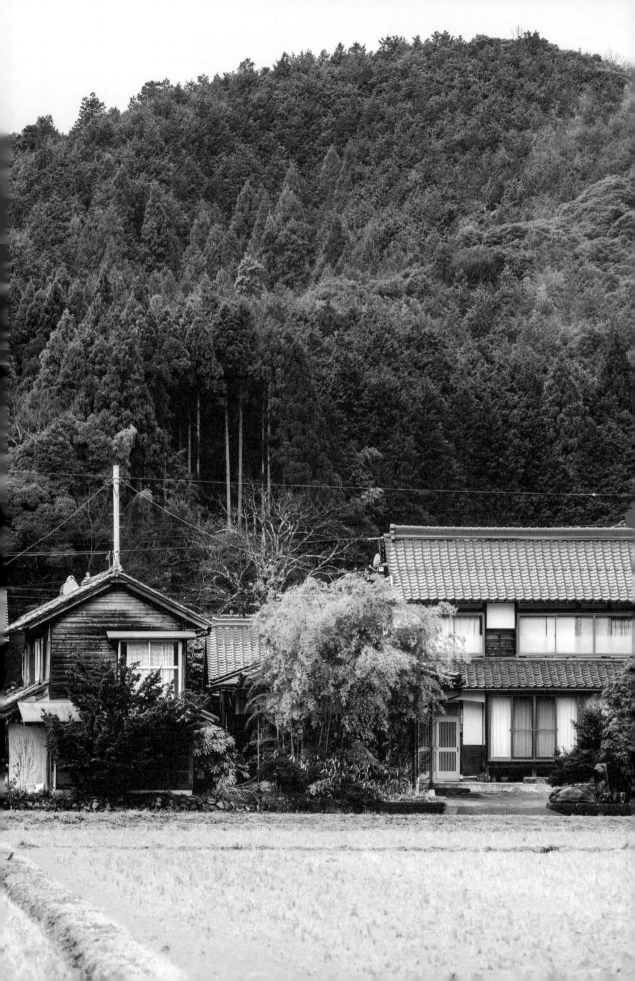

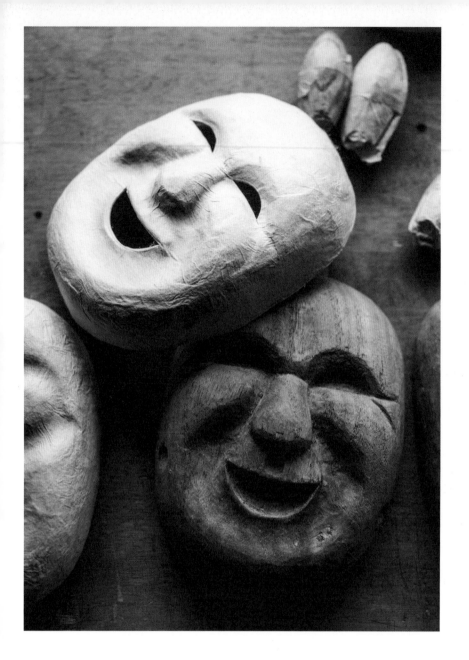

The word *mingei* was coined more than one hundred years ago by the philosopher Soetsu Yanagi, who discovered great beauty in the simple goods produced by Japanese and Korean craftsmen.

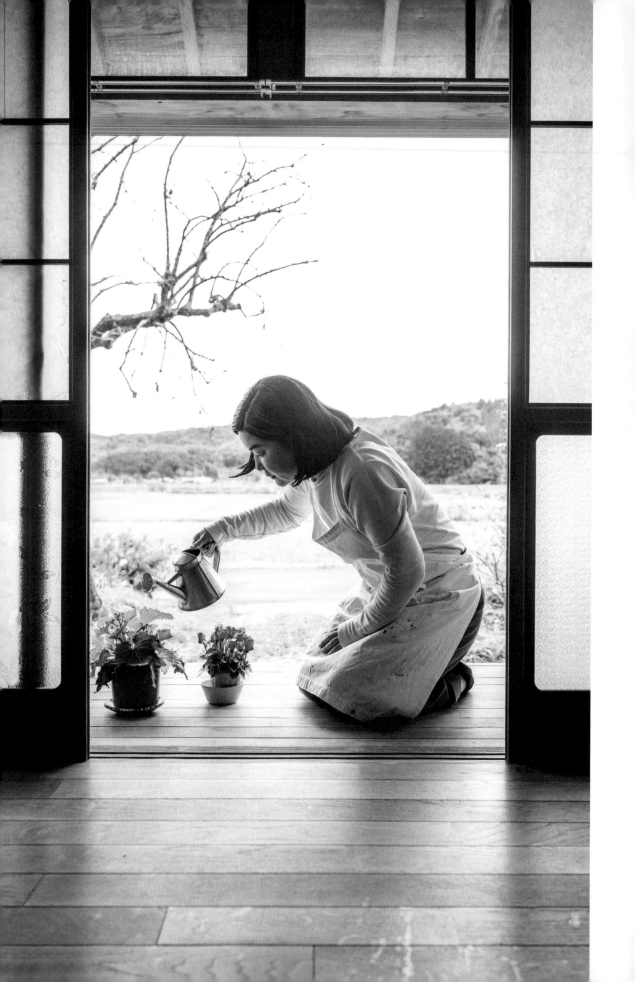

At first, Kawasaki was part of the in-house design team. Later, she became the director of the Found Muji project. "Since 2003, Muji has been scouting Japan for products that are 'simply good', even if they might be old", she says. Kawasaki's work took her up and down the country as she listened to the stories of all kinds of makers, from factory workers to craftsmen.

The reason why Muji finds it so important to connect with other makers is because of their strong relation to *mingei*, or folk crafts. The word was coined more than one hundred years ago by the philosopher Soetsu Yanagi, who discovered great beauty in the simple goods produced by Japanese and Korean craftsmen. Today, his book, *The Beauty of Everyday Things*, is still sold in museum shops around the world.

Yanagi celebrated crafts, praising the beauty of objects that were made by workers without any artistic intention, such as a potter with no name. Mingei is about the beauty of everyday things rather than about high-end craftwork of perfect quality and artistry. "Some people say Muji is the present-day mingei," Kawasaki explains. "They make ordinary products that everyone can afford and that are simply 'good enough'. During the eighties logo craze, when Muji was founded, a product's price was determined by its name rather than by the product itself. Muji was the antithesis of this trend." Instead, Muji and its predecessor, mingei, shine a light on the beauty of the humblest products.

—

About seven years ago, Kawasaki decided to quit her dream job and return to Tottori. "As I grew older, my interest in design outweighed my desire to live in Tokyo. Being a designer, I also continuously analyse every man-made object that I see. As a consequence, my brain never gets any rest in an urban environment. I prefer a place with less design, such as the countryside."

Since 2020, Kawasaki has participated in a local project called Yanagiya Reproduct. It is run by local craft shop Cocoro Store as part of an endeavour to revive the legacy of Yanagiya, a Tottori studio that produced adorable traditional folk toys from 1928 to 2014. Yanagiya Reproduct has so far reproduced fifteen toys out of a repertoire of about fifty that Yanagiya had, from wooden puppets to paper masks. Kawasaki crafts four masks, which, unlike the scary ones used in *Noh* theatre or the diabolical *tengu* mask with its long nose, are both funny and cute. One mask represents the White Hare of Inaba (the old name of a region in Tottori), the protagonist of a famous Shinto (the native religion of Japan, based on nature) folk tale. Other masks, such as a green-faced clown with a runny nose and a yellow-faced figure that clears the way for the Kirin-jishi lion dance, originated in local festivals.

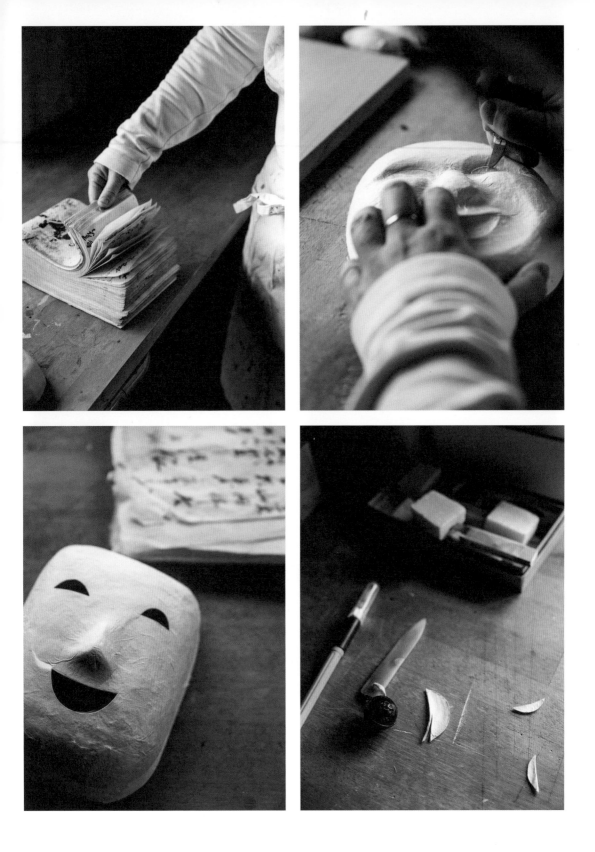

The masks are made using the *hariko* technique, which is very similar to papier-mâché. "I wanted to practice a craft that didn't require any tools or possessions", Kawasaki explains. "Hariko is exactly that. The result is light and ephemeral. It doesn't last forever." Kawasaki wants to flee the world of things. Sometimes, quite literally. Together, we visit the famous Tottori sand dunes, a vast stretch of yellow nothingness. Standing atop a dune, overlooking the crashing waves of the sea, with the swirling wind blowing freezing raindrops onto her red cheeks, Fumi closes her eyes and stretches out her arms like a bird about to take flight. Kawasaki is not cut out for life in the city.

—

Although Kawasaki comes off as sociable and energetic, she has a restless soul. To calm her mind, she decided to learn how to perform the Japanese tea ceremony or *sado* about five years ago. "Tea is the first thing that comes to mind when thinking about shosa", she says. "The goal of the tea ceremony is to allow guests to enjoy themselves. Every utensil has its place, and every movement is smooth so as not to disrupt the harmony of the surroundings. Ensuring every movement is minimalist and measured, that's shosa to me. You always move with the shortest distance in mind. You avoid making angles with your arm or hand. Every move needs to look beautiful."

To pull off this almost choreographed beauty, you need to follow every movement in this minutely prescribed ritual. "There's even a rule for how to place your feet on the tatami mat. Memorising the rules is not enough, though. Everything must be done without thinking. If you repeat these movements until they become second nature, you'll find that this clears your mind, and the right shosa will come to you. It'll feel like a meditation of sorts, an almost mystical experience. Suddenly, the conversation with your guests, the warmth of the water, the smell of the tea, it all becomes so beautiful. Instead of using your mind, you are relying on your senses."

On a cloudy day, Kawasaki takes us to Amidado, a small shack on the flank of a hill overlooking Koyama Lake. The room consists of nothing more than a wooden floor and a view. In a little backroom, water is boiling, and Kawasaki is preparing tea. While she pours it, the photographer and I sit in the *seiza* position – kneeling with our posterior resting on our legs and ankles. As we sip our tea, the clouds darken over Tsubu Island, a tiny swath of forest in the middle of the lake. Kawasaki returns, sits, and closes her eyes.

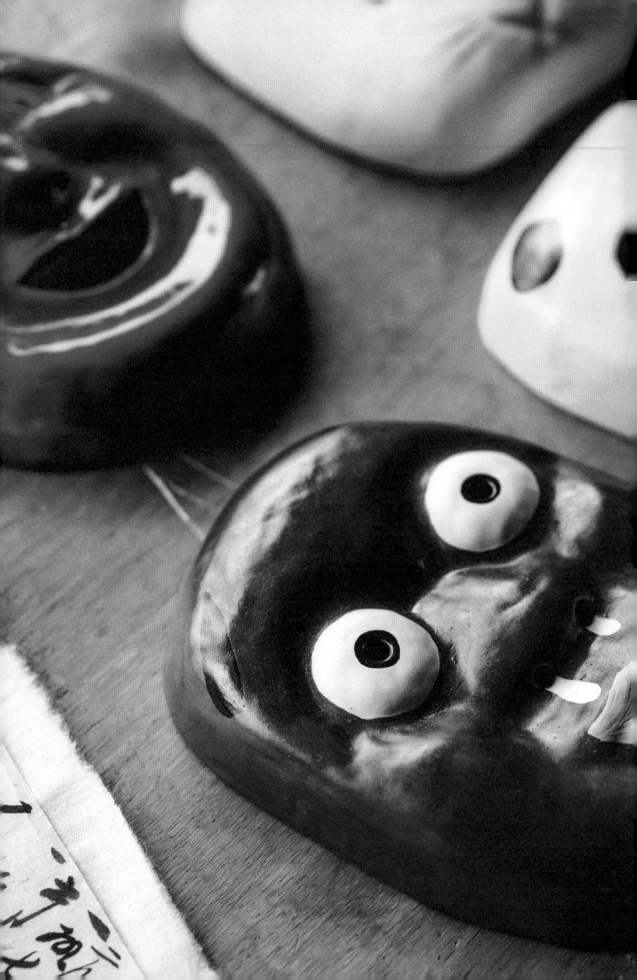

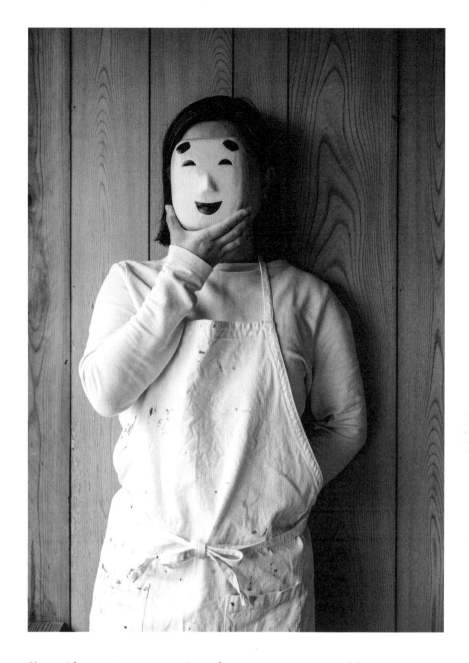

"Politeness and etiquette are all about obeying specific rules. Shosa is about the harmonious movement of the body. While etiquette is about right or wrong, shosa is about good or bad."

Moving in a measured manner to avoid mental or physical friction, like during the tea ceremony, can also be applied in daily life. "For instance, there are rules for opening a *shoji*, a sliding door, to avoid making noise or acting clumsy. We still learn some of these rules at home or at school: the exact angle when bowing, for example, or how to hold your chopsticks." But this is etiquette – *saho* – rather than shosa. There seems to be a fine line between the two. "Politeness and etiquette are all about obeying specific rules. Shosa is about the harmonious movement of the body. While etiquette is about right or wrong, shosa is about good or bad."

As for her craftsmanship, Kawasaki admits that she has not yet obtained the right shosa. "I still have to find the right movements and control my body while making the hariko masks. The more skilled I become, the more I'll avoid unnecessary movements. The hand gestures have to become automatic. Shoya Yoshida, a doctor and philosopher who promoted the Tottori mingei craftsmen, said: 'Make as many goods until your ego disappears.'" Work until the work becomes pure movement. "In a way, good shosa is similar to the work of a minimalist designer. Ultimately, he is trying to make something that is as efficient and pure as possible. He'll only add an extra line to the design when necessary."

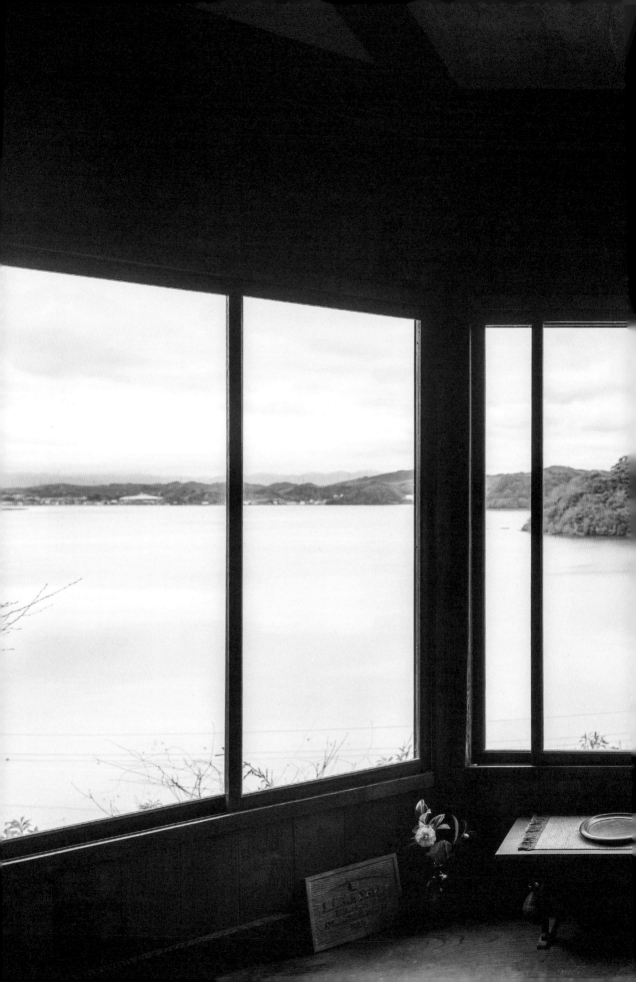

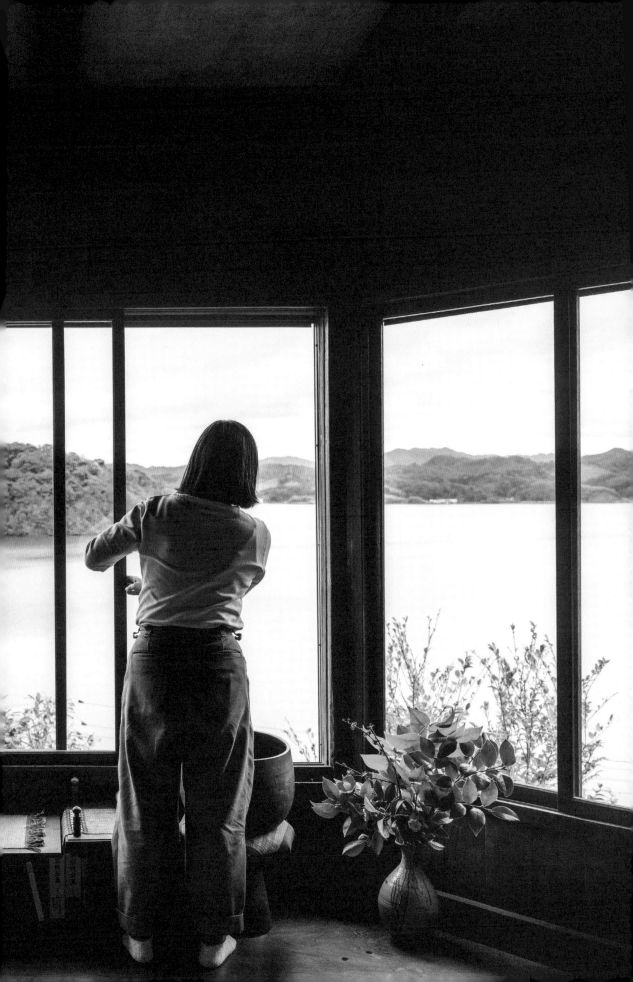

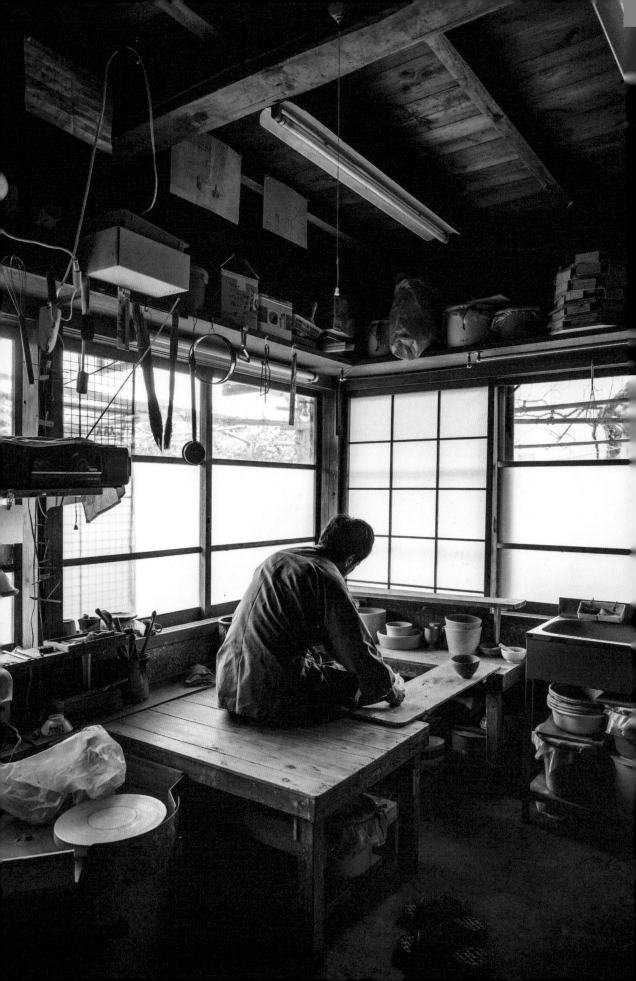

Thinking with your hands

Yasunori Ashizawa
Potter
Yazu

蘆澤保憲

The rural district of Yazu, our final destination in Tottori Prefecture, lies at the foot of the Chugoku Mountain range. The latter forms a natural barrier between this prefecture and the more urbanised regions near the Seto Inland Sea and the Kansai region, where Osaka, Kyoto and Kobe are situated. Here, in a seemingly nondescript street, lies a beautiful three-hundred-year-old, sloped kiln named Inkyuzan. In Japanese, its name is written with the characters 因久山, meaning land, community and mountain – or kiln, for that matter. As such, the name denotes its function as the official Tottori clan kiln for potters of the community since the Edo period.

"In all these years, the kiln hasn't moved or been altered, except for the bricks on the outside", Yasunori Ashizawa explains. He is the tenth generation to manage this kiln. "They need to be renewed every fifty years or so." In the Edo period, Tottori pottery was used as a gift by people of the region who were travelling to the centre of power, Edo City, now Tokyo. The kiln was, therefore, lit about twenty-two times a year.

Today, Ashizawa uses this wood oven once every three years, firing about three thousand ceramic items at a searing temperature of 1230°C. Using the old seven-chambered kiln is a tedious task, as it burns for fifty hours straight. Six men keep a close watch over two days, ensuring the temperature of every chamber in the kiln is maintained, adding red pine to the fire whenever needed. "The others work in shifts and take a nap now and then, but I have to stay put during the entire process", Ashizawa explains. "The traditional ways of maintaining the temperature are very strict and passed down from generation to generation. However, nothing is written down or even explained. You learn with your body."

Nowadays, the fire temperature can be measured with a thermometer, but in the olden days, the master determined it by looking at the colour of the flame and using small test samples. "However, every part of the process, such as the amounts of wood that are thrown in at specific times, is still the same. The baking never takes exactly fifty hours. My responsibility is to determine when to kill the fire."

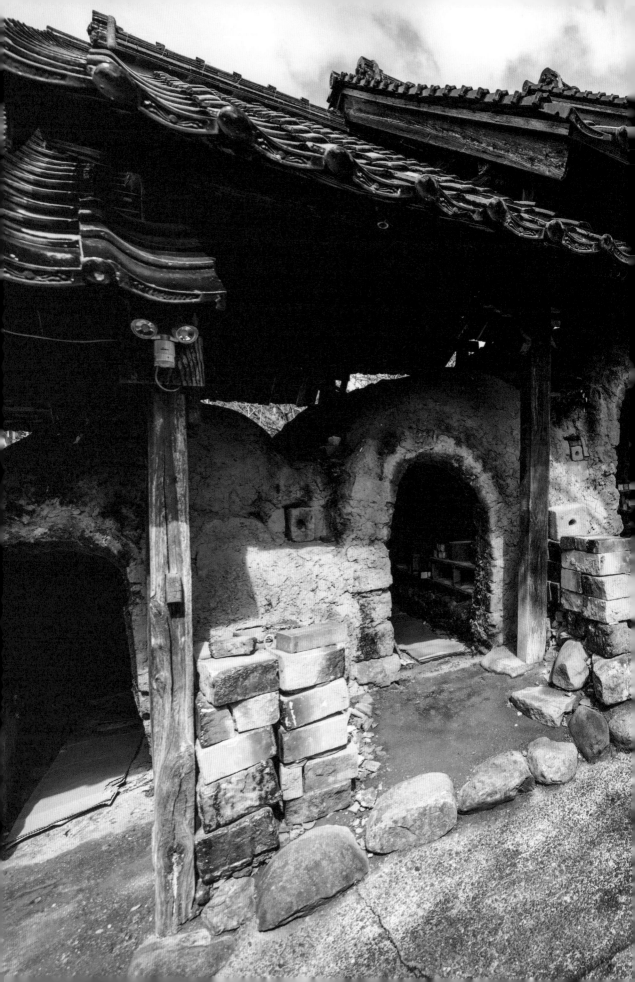

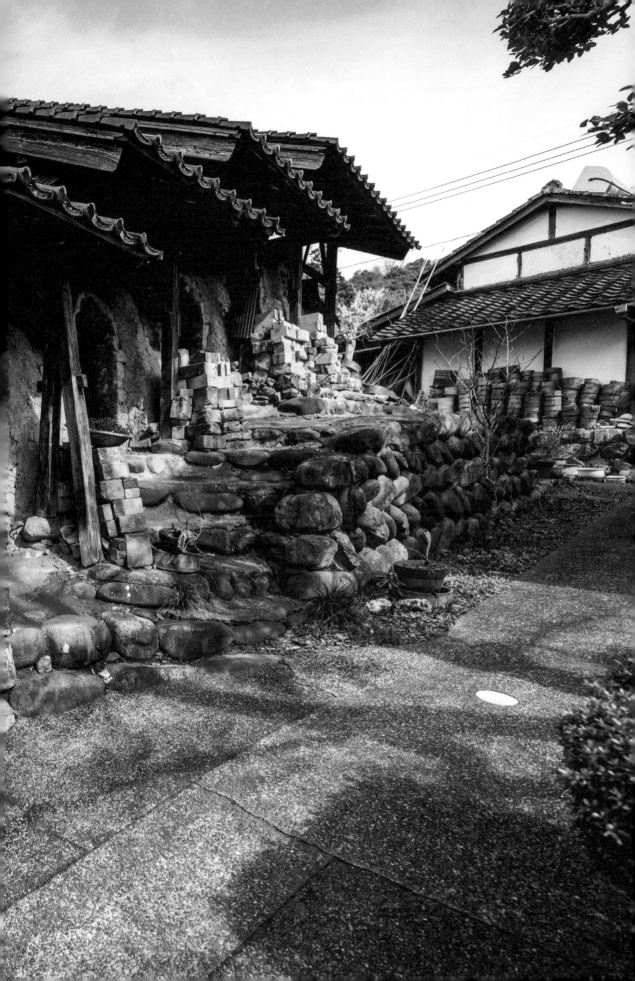

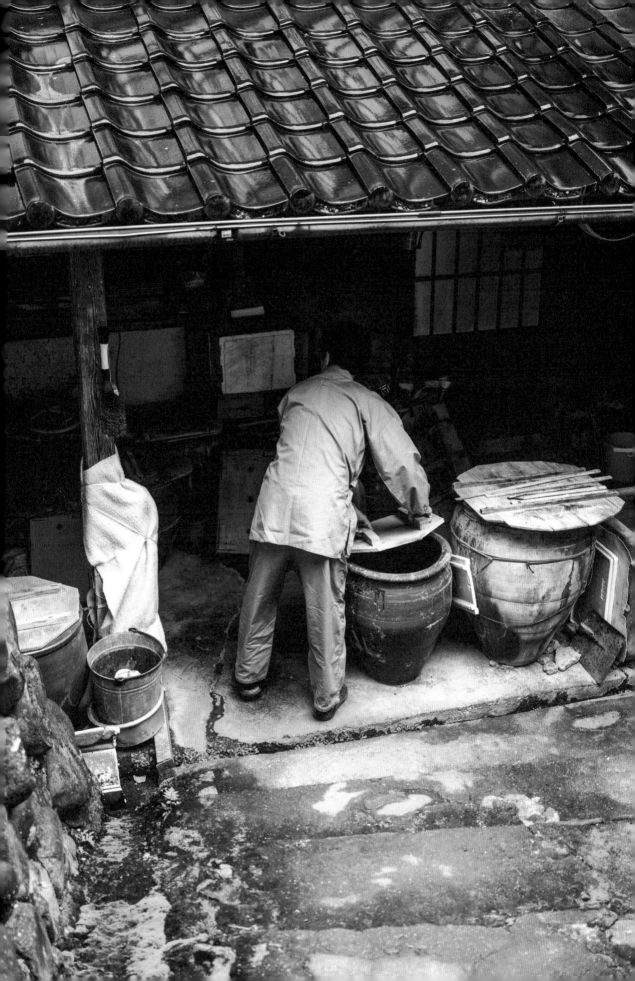

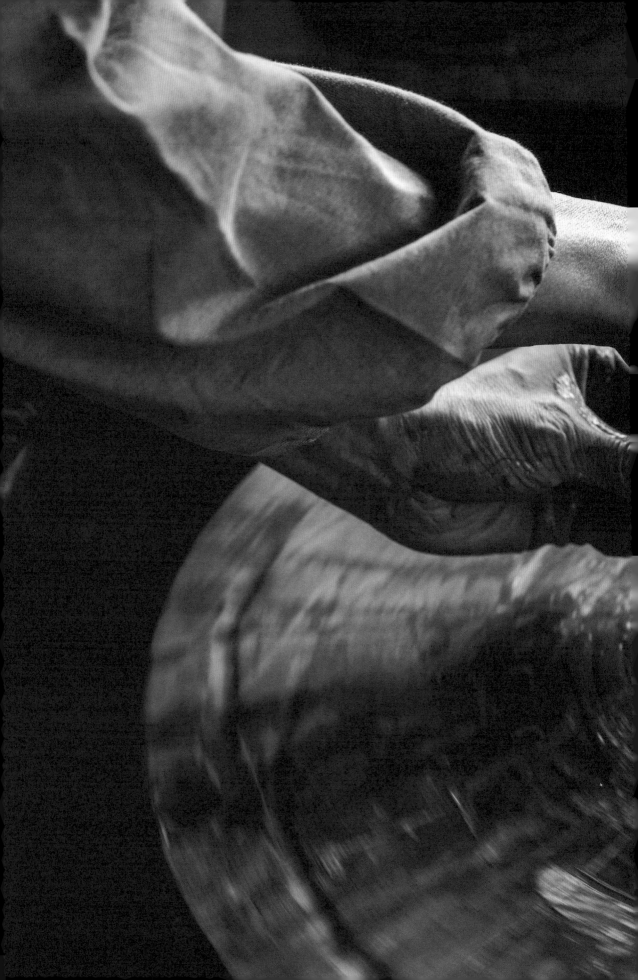

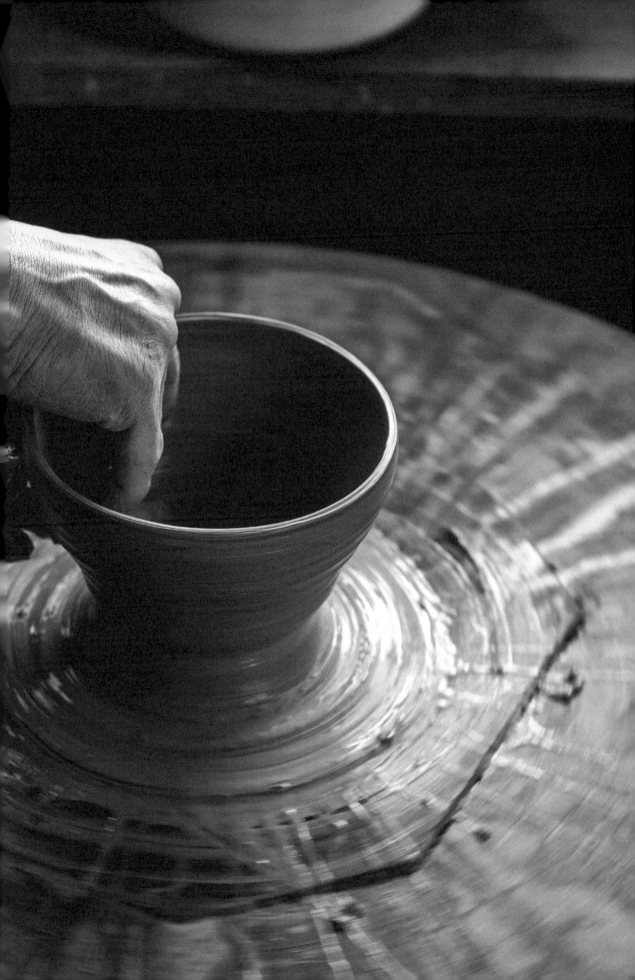

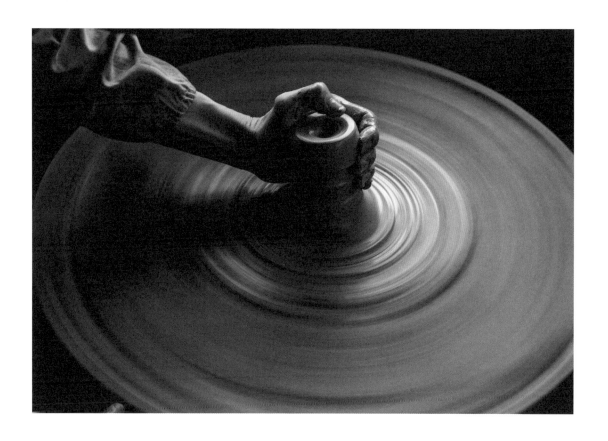

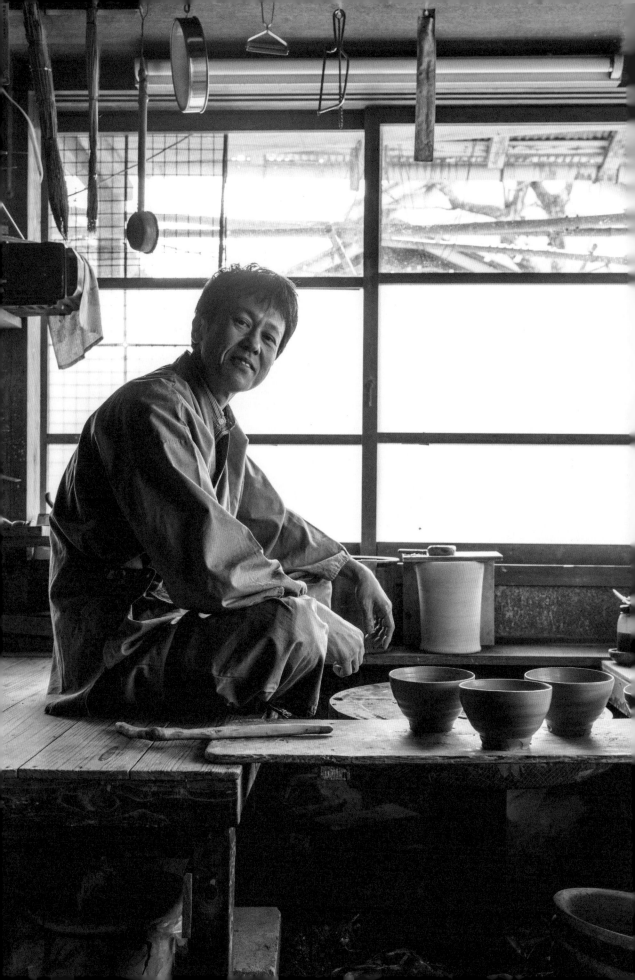

We ask him: What does shosa mean
to you? *"Hm, so desu ne."* - "Hm, yes",
he sighs. "It is an important concept
for the Japanese. For me, shosa is
about reducing your movements,
eliminating anything unnecessary
and concentrating while making a
bowl."

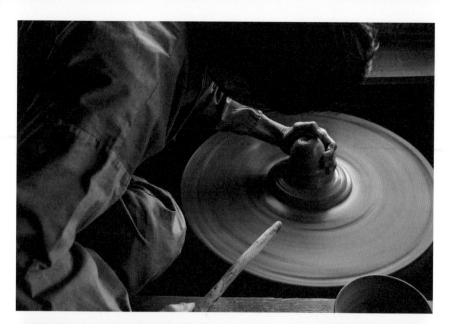

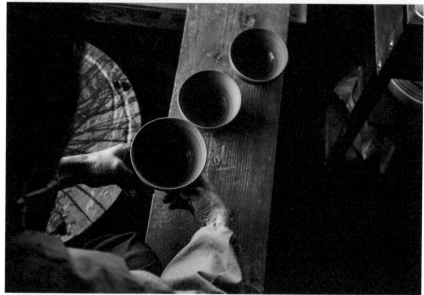

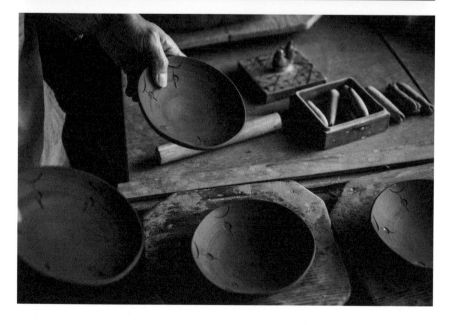

Firing up the kiln is a major event. "I tend to look forward to it, although I am nervous at the same time", Ashizawa explains. "I don't sleep well the last three nights prior to the event. Fire is unpredictable, and we have to do everything we can to make it slightly foreseeable. But it's worth it." Above all, it is about keeping the old ways alive. "To be honest, there really is no advantage to firing pottery in the traditional way. There typically are two firings. The first firing, called the biscuit firing, is done at 800°C without a ceramic glaze. The second, with a glaze, determines the colour and the texture of the final product. As the first firing doesn't really influence the final result, some potters prefer an electric kiln. Even during the second firing, the kiln might only have a slight impact on the final result." In short, firing pottery in the traditional way is a lot of added work for a minor advantage. But it is a wonderful example of folklore. "It's like a prayer. I pray to the fire: please work well."

—

In Inkyuzan, they mainly use five colours, which were set in Edo times. The glazes are made from natural products such as ash, stone grit and straw. One of the most remarkable hues is *shinsha*, a specific red developed by the eighth generation of the family. "This colour can only be produced in the first and lowest chamber of the sloped kiln, with a reduction firing", Ashizawa says, "where more carbon monoxide is generated." When the air lacks sufficient oxygen, the fire extracts it from the iron and copper in the glaze. This chemical reaction causes the glaze to turn red. "Although this red is produced all over Japan, it varies from kiln to kiln. It is hard to reproduce."

All ceramics are made from local clay. Outside the workshop lies a pile of soil with grass on top of it. "Our clay comes from this pile", Ashizawa says with a grin. "Again, there's no advantage to doing this. The local clay is actually not that great because it has a high shrinking rate, which leads to a lot of cracking. We add a specific stone grit to prevent this from happening."

It is clear that in Inkyuzan, keeping the tradition alive overrules a pragmatic approach. Ashizawa initially was hesitant to devote his life to the kiln. In fact, before 2000, he was doing something completely different. "After studying economics, I ended up working in a metal processing plant in another region, where they didn't know that the name Ashizawa is linked to this kiln. I didn't have a great relationship with my father. I also didn't like the traditional colours of the kiln. After some years, I returned and started making ceramics, although I didn't love it that much. Over time, I started seeing the beauty of not doing your own thing. Now, I never try to express myself. When experimenting with new glazes and shapes, I notice that in the end, the traditional way always prevails."

"Over time, I started seeing the beauty of not doing your own thing. Now, I never try to express myself. When experimenting with new glazes and shapes, I notice that in the end, the traditional way always prevails."

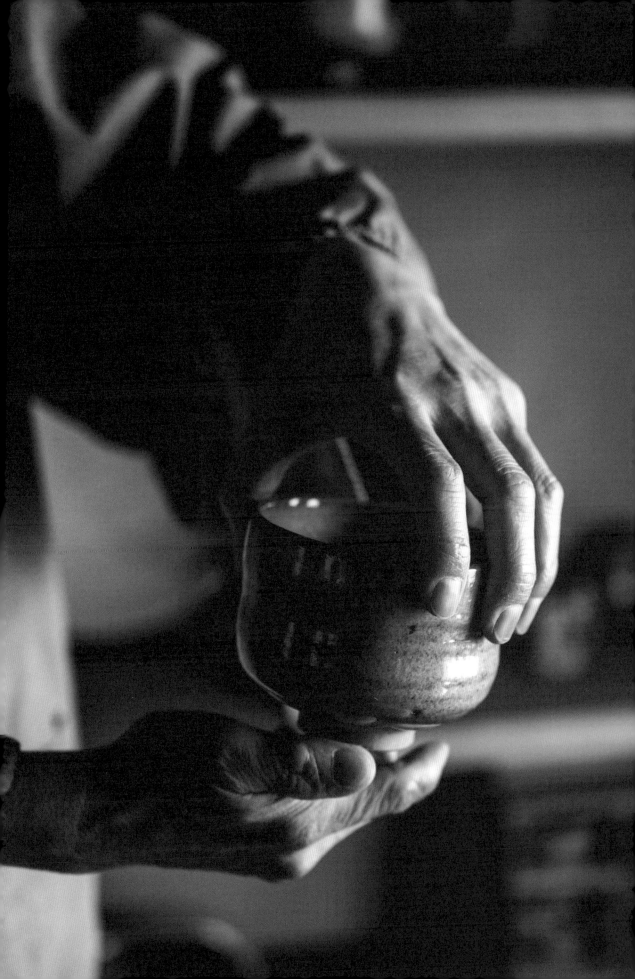

When it comes to making pottery, Ashizawa draws on the very origins of the Inkyuzan tradition. Apart from having an electric turntable, he sometimes sits cross-legged behind a hundred-year-old massive wooden wheel that's not powered by electricity or a mechanical kick. He uses an old pistol-shaped stick to give the table a big turn. During the few seconds in which it spins fast, he shapes a heap of clay with one hand. After three minutes and a couple of spins, his *chawan* (tea bowl) is ready, and Ashizawa is panting. "For me, this is the core of a turntable. I still use this one for the more precious bowls. You can't make big pieces, though, because my arm and the stick are in the way. It's fun to use. It's difficult on your body, but you can still feel the sensation of turning the wheel in your arm the next day", which he likes.

We ask him: What does shosa mean to you? "*Hm, so desu ne.*" – "Hm, yes", he sighs. "It is an important concept for the Japanese. For me, shosa is about reducing your movements, eliminating anything unnecessary and concentrating while making a bowl. I try to improve my shosa every time I work, trying to make every movement more sophisticated. Actually, shosa is more of an attitude that inspires you to move in a certain way. Masters such as my father, they have a perfect shosa. As a result, all the work he produces is beautiful."

"Look at this plate, for instance," he says while showing us a rectangular ceramic plate with a simple wave relief on it. "I made it about twenty years ago. It represents a sand dune. As you can see, I've tried to capture the wind in the sand. But it is too designy. If you get inspired by an image, you tend to copy it rather than make an abstraction of it." He shows us three bowls: three interpretations of a snowflake. "The first one was too literal and not well-thought-through. The second one is the best: it's abstract, yet you can see the snowflake in it. With the third one, I took the abstraction too far, overthinking the design. If you try too hard, it may look pretentious." Ashizawa touches on a very interesting subject: purity in creation. For him, this can be achieved with shosa, by having the right attitude and state of mind while working. Focus and a clear mind give rise to thoughtful but not overly designed objects. In other words, shosa is synonymous with perfectly balanced work that is devoid of decorations and simple and pure in all its perfection. The ego should be eliminated. Let the hands do the thinking.

Shosa manifests itself in the movement of the hands as well as in the final product. "But I'm not quite there yet," Ashizawa says. "I've only been using the old turntable for about twenty years. I'm still too conscious about my shosa. I work better at the old one than when I'm using the electric one, though. I don't think of anything else: just the repetitive sound that lingers in the room. I hear it even when I sleep."

"The concept of shosa is gradually disappearing", he adds at the end of our conversation. "I wonder if it will survive." He is, of course, referring to craftsmen who work on a product with their full attention and deference for the finished product. "Nowadays, you can buy anything, anywhere. I hope the culture of treating objects with respect will somehow be preserved."

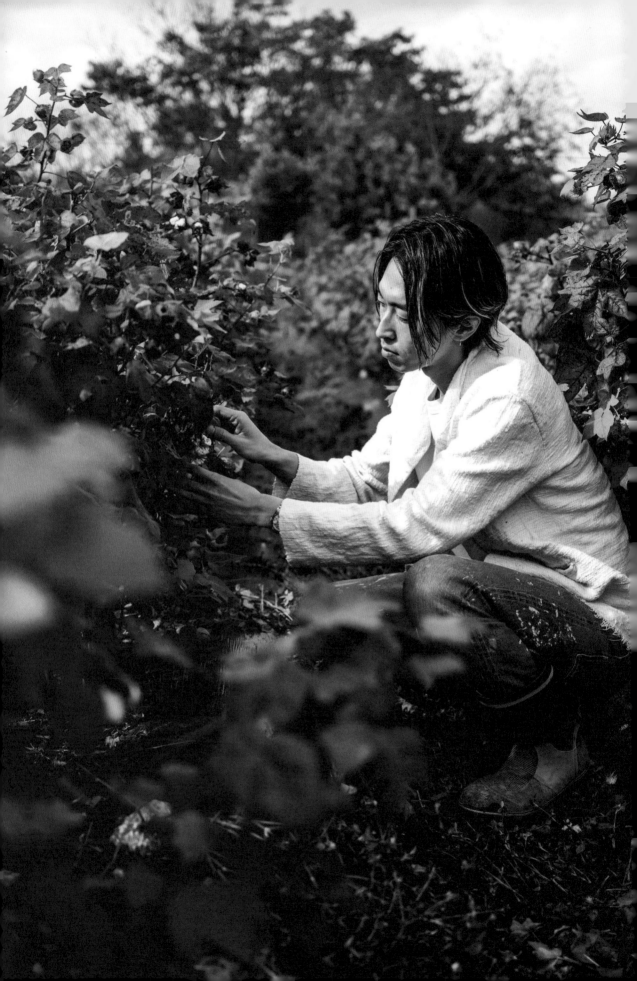

Carving
out time

Tomohiro Kishida
Maker of clothing
Kashiwara

岸
田
朋
大

"Actually, this is the place I used to come for a haircut as a kid", Tomohiro Kishida says when we enter his workspace. From the outside, the building looks just as inconspicuous as the rest of Kashiwara, his hometown on the border between Osaka and Nara Prefecture. On the inside, Kishida painted all the metal walls a neutral light grey, creating an immaculate background for all his wooden tools, including a loom and a spinning wheel. Apart from a laptop, there is no technology here.

"It all started with an urge to make things with my own two hands", the young craftsman explains. "I initially studied architecture, but soon I realised that I wanted to design on a more human scale. I then switched to ergonomics with the idea of becoming a furniture designer. During an internship, I quickly realised that I didn't have much affection for furniture. At that point, I felt lost, so I went to work as an engineer for Panasonic. In this job, I came to understand that companies are mainly driven by economics and that I wanted to put my heart and soul into my work. And so I came to the conclusion that I would only find some peace of mind if I would do something with my hands."

He enrolled in a fashion course in Osaka because he felt that it was an art form that would allow him to experiment and work on his own. During his studies, Kishida discovered a three-hundred-year-old Japanese weaving technique that would change the course of his life and career: *sakiori*. The word means tearing and weaving. "You tear an old cloth into thin strips and then weave them into a new fabric", Kishida explains. "The technique is not exactly popular among young people, and certainly not in Osaka. It was mainly used in Northern Japan, where cotton was scarce. Old worn-out kimono, for example, were recycled that way."

"Technically speaking, it isn't difficult, but it requires a lot of handwork. So, from a time perspective, it is a challenging technique for people today who think in terms of efficiency. For me, making sakiori is akin to meditation. I consider it a luxury to spend my time in this way." The result is steeped with the charm of handwork.

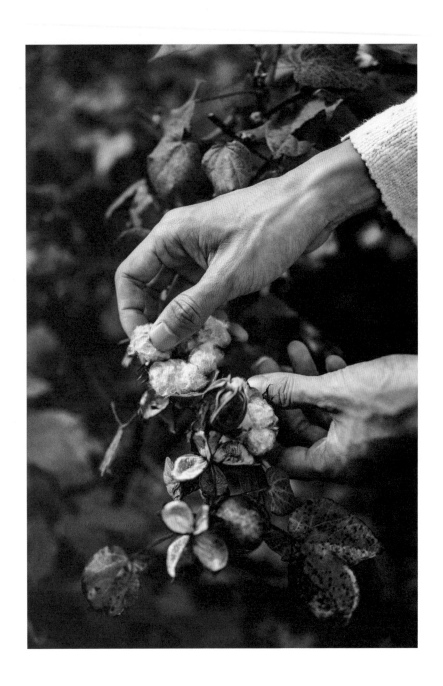

Kishida discovered sakiori by accident. "At school, all the students had to use simple white cotton cloth for their assignments. After the teachers judged the garments, they were thrown away. I thought this was quite a shame. As students, we became waste-producing machines." He started recycling the waste of his fellow students using the sakiori technique, first into shawls, then into clothes. "The funny thing is that originally, sakiori was developed to deal with a textile shortage. Now I use it to highlight the insane abundance."

—

After some time, it became clear that recycling textiles was not enough. Kishida wanted to go back to the very core of fashion. For about five years now, he has been growing his own cotton in a nearby field to create garments from scratch. He recently even moved from the city to the small town of Kashiwara to be able to spend more time in the fields. The land belonged to his grandfather, who cultivated grapes. Kishida: "Although some farmers in this region plant them for wine, my grandfather's harvest was used for food. After he became too old to do hard work, I use some of his land for cotton. That way, I'm not only going back to the core of fashion, which is farming, but also to the roots of my family." In the beginning, his father, who is a dental engineer, complained about his son's return to blue-collar work. Now, he occasionally helps him in the fields. "This is where he was raised, where he watched the grapes ripen. He enjoys the work."

In May, Kishida plants the seeds, and in October and November, he harvests the cotton balls. After that, the strenuous job of removing the seeds from the cotton balls begins. The next steps are carding the cotton (rolling the fibres in the same direction), spinning the yarn and boiling the yarn in order to retain its whirl. After this exhausting process, he can finally start to weave. Every step is done alone and by hand. "I use tools, not machines. If I used a machine, then the whole point would be lost."

The amount of work that goes into making the clothes is insane. Kishida's mindset is awe-inspiring. Here is a young, fashionable guy living in the countryside, forgoing all mod cons to make a point. Similar to the exemplary function of a monk who leads an austere existence, Tomo demonstrates the core principles of fashion by going through the entire production process on his own and manually.

—

Shosa is important to Kishida. "I learnt the word from a close friend who one day came to visit my studio. He was watching me weave. Out of the blue, he said that the weaver's movements might be just as meaningful as the finished product itself. I was new to weaving back then and didn't fully grasp what he was saying. But over the years, his words became more and more important to me."

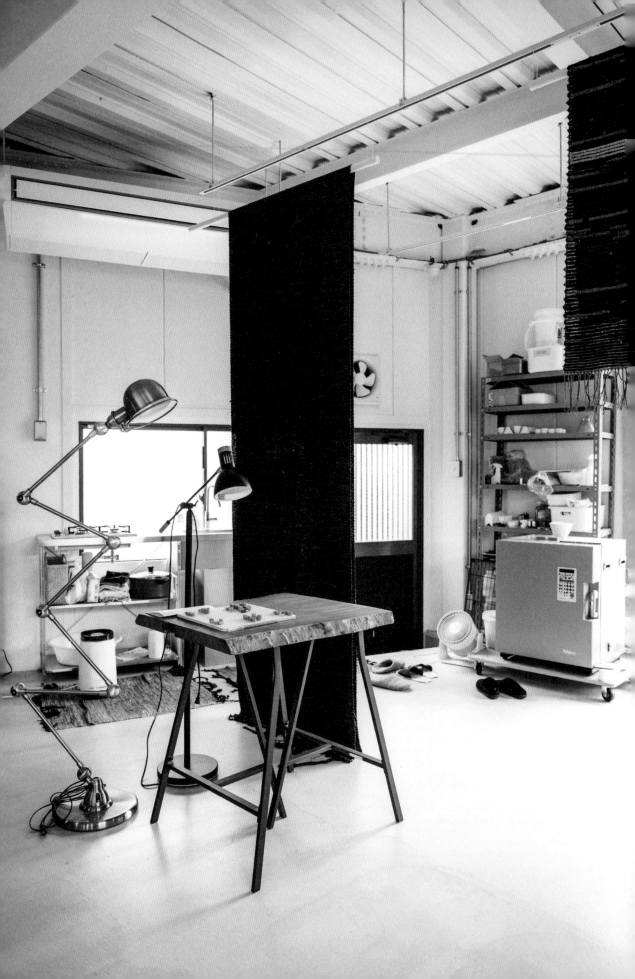

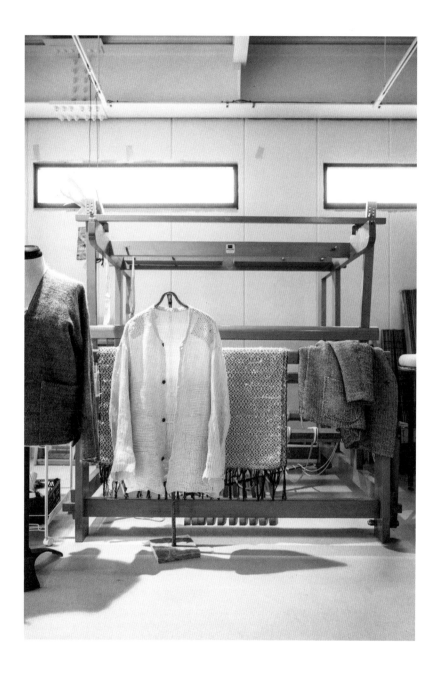

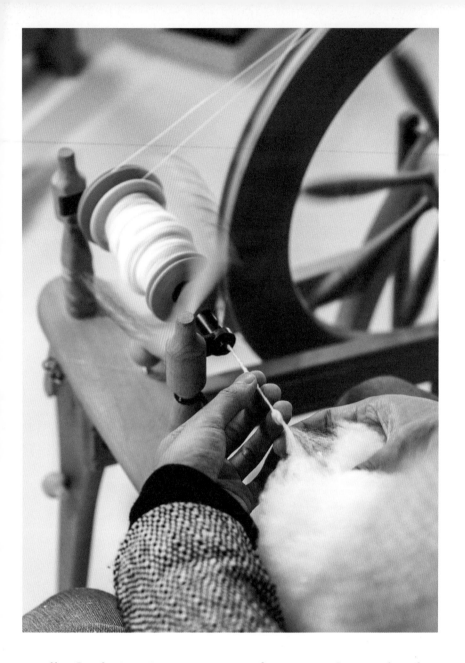

"I finish about two pieces of *sakiori* a month. For the cotton project, I've made about ten pieces in five years. That's not a lot, isn't it?"

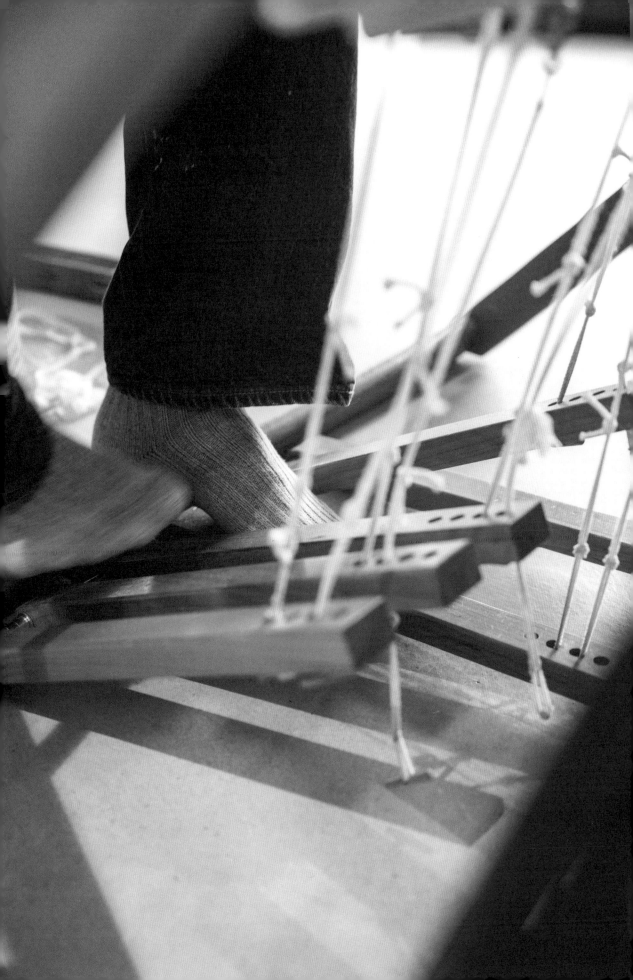

"For me, the main elements of shosa are continuity, repetition and a sense of time. I focus on the movement itself and nothing else. If you start thinking about the final product, it'll be no good." Meditation then? "For me, shosa approximates this. It's not about making something beautiful but rather just about making."

Repetition is a key component in many methods designed to relax the mind. Think of daily routines that offer structure and calm or how monks chant mantras. Repetition mends the soul. "During the repetitive movements of weaving, I feel time accumulating; it becomes a thing of its own", Kishida says. Time becomes something else than the stretch of minutes or hours we all tend to fight against. By focussing on a repeated movement, Kishida carves out time, making it almost tangible. Time is no longer an obstacle but an enriching part of the process. Time becomes pure.

"These days, in fashion – actually in every industry – production is all about efficiency, about limiting the time needed to produce something. I feel that when the making process is too fast, it will reflect on the consumption of the product. Handwork takes a lot of time, and every action in the production process has its own significance. The person who buys it will sense that a lot of feeling went into creating the item."

Efficiency, which is about limiting the time needed, is not relevant for Kishida. His movements while weaving, however, do seem to dictate some form of conciseness and efficiency. "This is the result of many long hours of repetitive work. You automatically start to eliminate all unnecessary movements. But that isn't the goal. Shosa isn't about efficiency or moving in a beautiful way. That would be meaningless. The fact that you, as a maker, put time and effort into it, that's what counts. That's the beauty of it." Spending hundreds of hours making a product doesn't imply shosa – that's just being busy. For Kishida, however, it means spending all your time repeating one specific movement while being entirely focused on it. You need to truly savour time, to feel it grow thick.

When you kill efficiency, you kill profit. "I finish about two pieces of sakiori a month. For the cotton project, I've made about ten pieces in five years", he laughs. "That's not a lot, isn't it? Seeing as I do everything myself, I thought I should also manage the sales. I want to be in control and be responsible for everything. In the current fashion production model, nobody takes responsibility for anything outside of their part of the puzzle. This has led to the problems we see today."

Kishida is constantly looking for new ways and collaborations that sidestep the problems of today's fashion system, but it is a slow and experimental work in progress. High fashion may not be fast fashion, but it might still be 'too-fast-fashion', for the garments change every season. The problem of fashion is the word itself: clothing that is in and out of fashion. "Although I have a rebellious attitude towards the contemporary fashion system, I would like to make a peaceful and positive contribution. I have no intention of picking fights. I don't hate fashion. On the contrary, I like it. But something has to change."

On a small table in the studio, I spot some silver buttons. Recently, Kishida started to make these himself as well.

Tomohiro Kishida — Maker of clothing

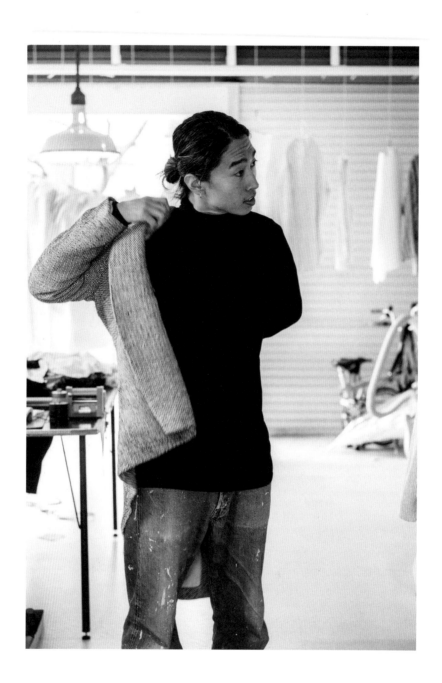

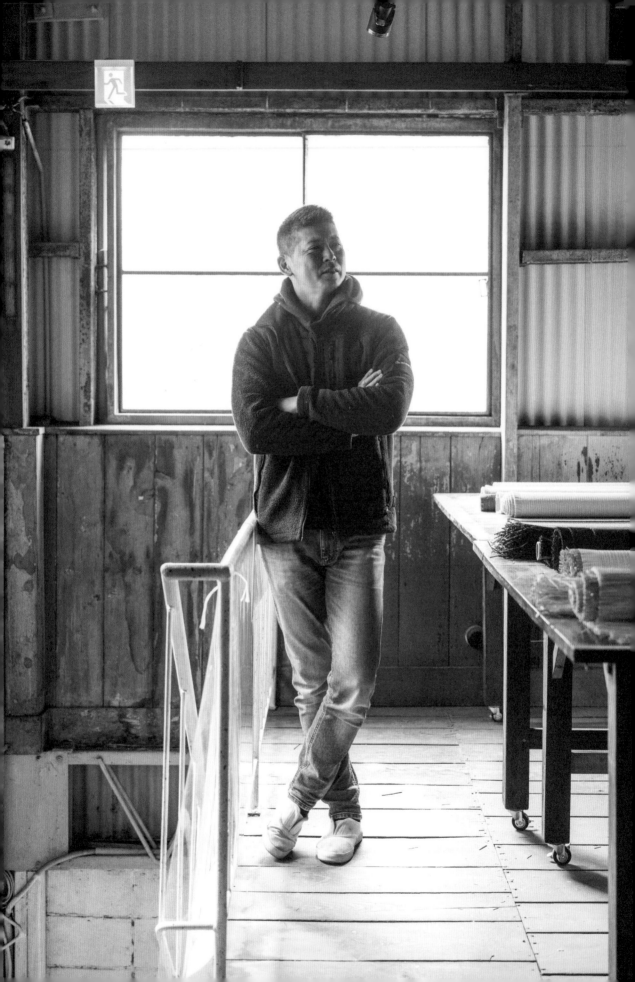

The very basis

Mitsuru Yokoyama
Tatami maker
Ohara

横
山
充

Given that Kyoto continues to be the epicentre of traditional Japanese culture, it was a given that I would end up here during my quest to understand the word shosa. I must admit that my feelings for Kyoto are somewhat mixed. On the one hand, the city's landscape is slightly different from other Japanese metropolises. A large part of Kyoto still consists of low-rise buildings in a checkerboard pattern packed with small shops, beautiful old *machiya* – traditional townhouses – and temples. Various rivers wind through that checkerboard, the Kamo River being the most interesting one. On its green banks, a group of youngsters in matching T-shirts practice their dance moves to the tunes of a boombox, a seemingly lonely student blows his first unsuccessful notes on the saxophone, and a woman reads a book while runners pass by. All this happens against the backdrop of a beautiful mountain landscape. The Kamo River offers an open-ended resting area, a rare thing in a Japanese metropolis.

On the other hand, Kyoto is a city plagued by over-tourism, similar to Venice in Europe. Much of the charm of its centre has been sacrificed to the sport of sightseeing. Overtourism creates a reality in which people start to behave like visitors to an amusement park. I remember the time when I sat on the wooden palisade of Ryoan-ji, staring at the world's most famous Zen garden. While the sea of pebbles poignantly portrayed the emptiness of the mind, tourists jumped around as if it were Disneyland. Many tourists might have poor shosa.

"These days, they arrive in busloads", says Mitsuru Yokoyama, who lives with his wife and two children in Ohara, a picturesque village just above Kyoto that was previously untouched by tourism. The local Hosen-in temple, where you could stare at a seven-hundred-year-old pine tree all by yourself, is now overwhelmed. Visitors sit cross-legged in their polyester shorts on traditional tatami mats made of nothing more than rice and grass, a flooring of extreme serenity that has also defined the Japanese aesthetic over time.

"Whether you practise *ikebana* (flower art) or perform a tea ceremony, all traditional Japanese activities take place on the tatami mat. It's the basis of everything. In real estate, the size of a room is still indicated by the number of tatami mats you can fit into it."

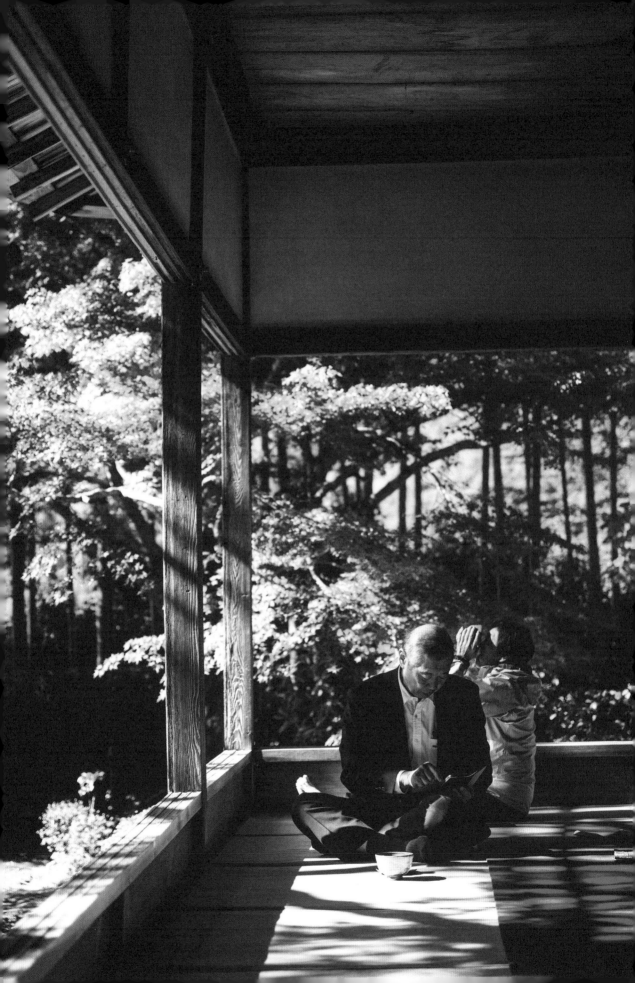

At Hosen-in, the tatami flooring is made by Mitsuru's strong hands. "I've always been more of a hands-on guy, and as a consequence, I didn't feel that I fitted in in Japanese society," he says. "I grew up in Tokyo and Yokohama (a city west of Tokyo). When you live in the city, you're supposed to go to college and then become a salaryman. That's what all my friends did." Instead, Yokoyama did odd jobs, making just enough money to buy himself a plane ticket. His goal was always to leave Japan. In 2001, after having made some trips, Yokoyama took a big leap and moved to New York, where he lived for six years. "I didn't speak any English and didn't have any money. Two months after my arrival, 9/11 happened. I heard the explosion."

In New York, he earned a living as a dog walker. "In Chelsea, there was a French guy who had fifty dogs! It was good money. I also worked as an assistant for a photographer who still shot analogue." After New York, he moved to France and later ended up in Australia, where he worked on boats for seven years. "I just went to the docks and asked for any type of work." Although his story reads like an episode from a Kerouac novel, he brushes off my compliments. "I wasn't brave, just naive. I had nothing to lose."

In Australia, the adventurer met his wife, which forced him to rethink his life. "I felt I had reached the limit of what I could do with my hands in Australia," he says. "In fact, anyone could do my job. At the same time, I noticed a great interest in Japanese crafts from Western people. In these crafts, handwork is still a highly regarded skill. I decided to head back and learn a craft. I made this decision about sixteen years ago."

—

Yokoyama eventually chose the profession of tatami maker for purely practical reasons. "Whether you practise *ikebana* (flower art) or perform a tea ceremony, all traditional Japanese activities take place on the tatami mat. It's the basis of everything. In real estate, the size of a room is still indicated by the number of tatami mats you can fit into it. A tatami has two standard sizes. The Kyoto style measures 191 by 95.5 cm, and the Tokyo-style tatami 176 by 88 cm. Housing is usually measured in Tokyo-style tatami, temples and machiya in the older Kyoto-style."

To become a tatami maker, you go to a tatami school in Tokyo or Kyoto. "I chose Kyoto because I find Tokyo a terrible place. It's way too busy for me. The training takes four years. All the students are sons of tatami makers and go to school to learn the theory while gaining experience at their parents' companies. The principal was surprised that I showed up, seemingly out of nowhere, but was kind enough to offer his support. During the training, I worked from nine to five at a tatami maker and took classes in the evenings. In the factory where I learnt the trade, they produced hundreds of tatami each month. It felt robotic. After my training, I stayed there for five years and then started my own business."

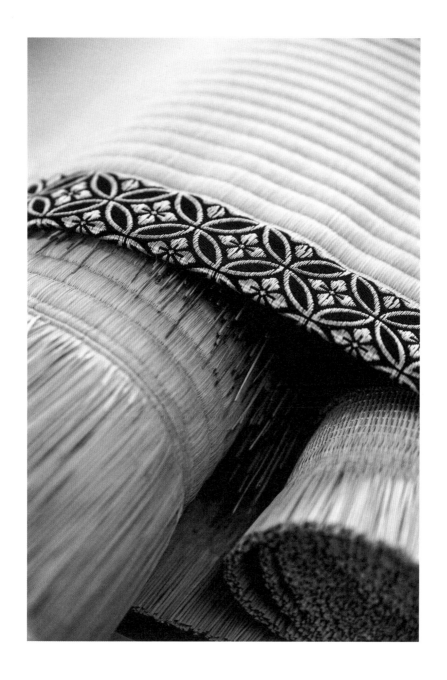

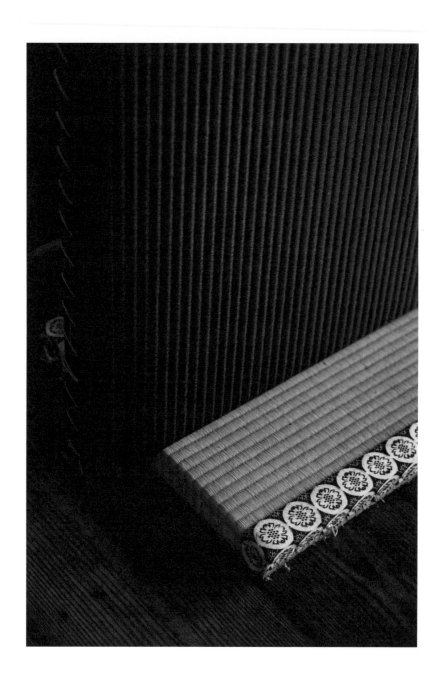

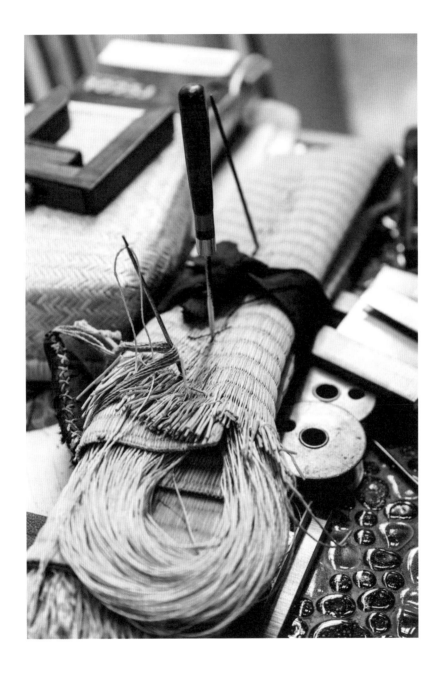

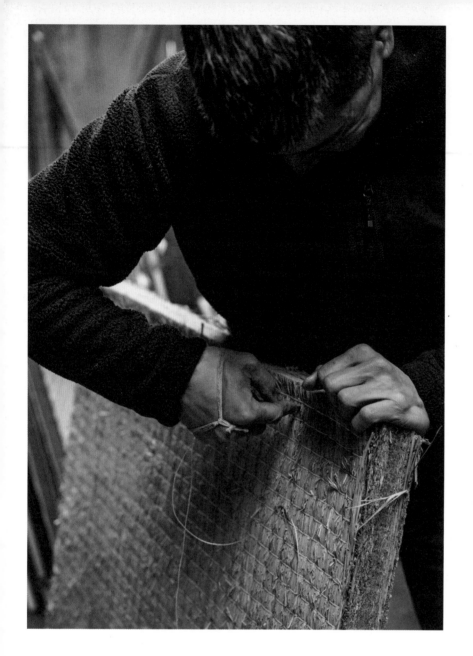

"Shosa is about moving in a pre-scribed way. This is the case in traditional tatami making, which you learn at school. You keep your back straight and punch the needle through the mat while paying full attention to the movement."

A tatami is not made by one craftsman. The basis of the mat is made from the hay of rice plants and is pressed into a board by the rice farmers after the harvest. The top layer is made of *igusa*, a specific type of grass that is mainly grown and woven in Kumamoto, a prefecture in the most southern of the four big islands called Kyushu. The tatami maker's task is to sew the igusa to the base and line it with a cotton edge called *heri*. This heri is woven by another craftsman.

All this handwork means a tatami is a pricey but qualitative product. It is particularly ecological, soundproof, insulating and moisture regulating. It also has a delightful aroma that not every Westerner might fully appreciate. Its scent is reminiscent of hay. "The fragrance of a tatami is relaxing," says Yokoyama. "You feel as if you're in nature." Initially, tatami are green. After a few years, they turn a golden yellow.

—

In the workshop, I watch Yokoyama at work. Although he was taught to sew by hand, he now uses an old sewing machine. "Sewing by hand is very time-consuming and quite unnecessary for many of the tatami jobs I get today," he says. "Even with this machine, it still takes a day or more to make a tatami." Yokoyama is a pragmatic man. What does an old word like shosa mean to him? "The word refers to how you move, behave and even dress," he says after some consideration. "Take, for instance, the perfect posture of a craftsman at work in an indigo kimono." He paints a portrait of a traditional maker. Can't shosa be applied to him? "I wear worn clothes", he laughs. "My movements might not be shosa, but my product is. The tatami is the basis upon which traditional Japanese life unfolds. And thus, it is the basis of all shosa".

"Shosa is about moving in a prescribed way," he continues. "This is the case in traditional tatami making, which you learn at school. You keep your back straight and punch the needle through the mat while paying full attention to the movement. There's truth in this. Your sewing becomes better this way. To me, there's no singular right way to go about it. As you become better at your craft, you figure out techniques and movements for yourself."

Yokoyama's approach is a reminder that strict adherence to movements is not essential for crafting excellence. Just like Yokoyama diverges from traditional crafting methods, he also deviates from the product, leaving room for innovation. He embraces collaboration, teaming up with contemporary designers to produce tatami mats in contemporary colour schemes. He also offers a pitch-black variant of the tatami.

"Innovation is necessary to maintain tradition", he states. "If you don't translate the traditional product to today's needs, the product will disappear. Japanese craftsmen often have a fatalist mindset. They are good at doing one and the same thing over and over again. They stick with it until the very end. Westerners, on the other hand, find repetition boring and believe constant variation is necessary. I think I'm somewhere in between. I feel that if you don't change, you can't evolve. And if tatami makers continue to stick to tradition, this craft will not have a bright future. At the same time, I don't want to innovate too much. The tatami is already beautiful as it is."

His approach works. Yokoyama has become the go-to maker for many Western architects who want to implement tatami in their work. When the world-famous restaurant Noma came to Kyoto, they called him. He still sews by hand in a tribute to craftsmanship and also to preserve the legacy of traditional Japanese spaces where everything is made in a specific way. He shows us a little triangular glove with a piece of metal inside. You hold it in the palm of your hand and use it to push the large needle through the mat. "This little glove is the first thing that you make at tatami school from some leftover heri cloth." I look at his tanned hand in which the small, worn-off glove lies. It is beautiful. It is everything you expect from a Japanese craft. But also so unnecessarily strenuous.

Perfect hospitality

Michiko Hirokane
Sado teacher
Tokyo

廣
兼
宗
珠

"All is made from wood and soil. It's like a mountain hut."

Beyond a small, rickety bamboo gate, a stone path meanders through a miniature moss garden. At the halfway mark, you encounter a small stone water basin and a wooden ladle to cleanse your mouth and hands. A few steps further, a sliding door only half a metre high offers a glimpse of what is inside. After you have taken off your straw *zori* sandals and have managed to crawl through the hatch, you find yourself in a small and humble tatami room where the walls are made out of mud. It is quiet and dark. A lady in a kimono welcomes you with a soft voice.

I am in one of the two tea rooms of Hoan, and the lady with the soft voice is Michiko Hirokane. Although Hoan would look perfect in the remote *inaka* – the Japanese countryside – it is actually situated in the centre of Tokyo. As you step out of Hoan, you find yourself back on the streets of the busy metropolis.

The neighbourhood is called Kagurazaka. When you mention the name in conversation with a Tokyoite, they usually make one of two remarks. People either point out that it is an old part of the city, renowned for its narrow streets and cosy Japanese-style restaurants. You can even spot a few geisha there. Or they say something like, "Oh, the fancy neighbourhood with all the French restaurants." Kagurazaka, which is located northwest of the Imperial Palace, offers both, with slick condominiums and fancy Pilates studios, as well as old food shops and charming houses dating from the Showa period, the tumultuous era from 1926 until 1989, marked by war and the economic blitz.

Somewhere in the middle of this eclectic mix lies Hoan, which was founded by Hirokane to introduce guests to *chanoyu* (hot water for tea) or *sado* (the way of tea), the Japanese tea ceremony. "I started with the tea ceremony about twenty years ago," she explains. "I used to be a teacher. It all started very randomly. I wanted to be able to serve tea to my friends in the proper way. In the beginning, I didn't really take it seriously because I didn't realise the depth of it." She mentions that her student, Yuki, had the same attitude to tea in the beginning. "Now I realise its complexity and the sensations that come with it. If you truly grasp the tea ceremony, then you'll understand a lot about Japanese culture in general."

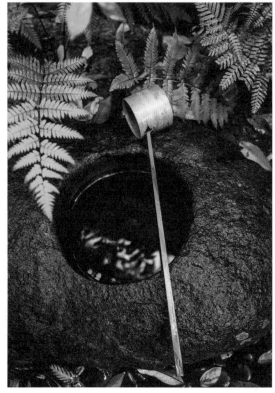

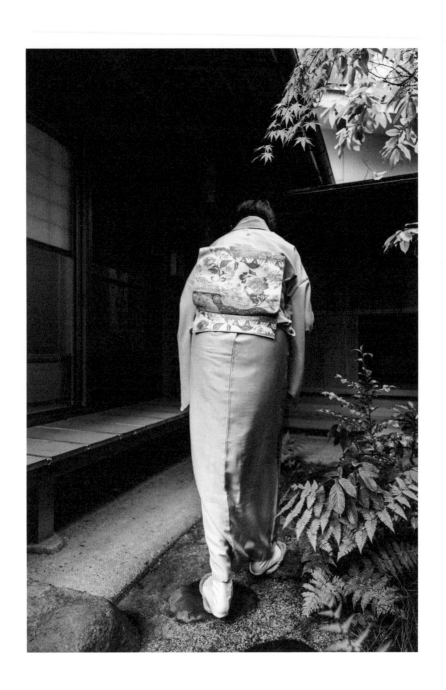

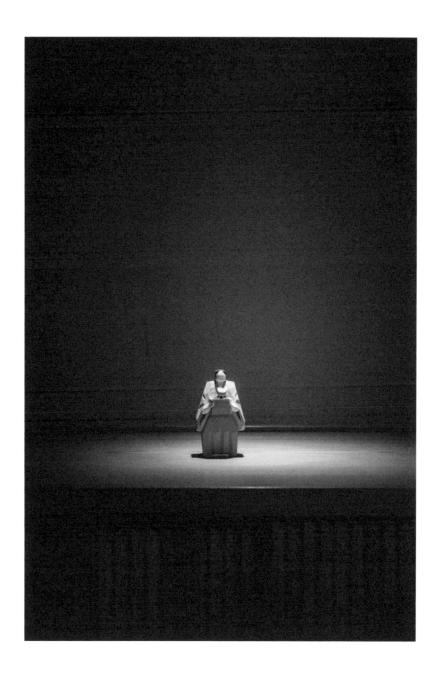

This is because sado gave rise to the philosophy of *wabi*, which in large part shaped Japanese aesthetics. The tea ceremony originated in Southern China during the Song Dynasty (960-1279), a culture that would go on to influence Japanese Zen Buddhism. In his famous *The Book of Tea*, Kakuzo Okakura describes the beginning of sado as follows: "Among the Buddhists, the southern Zen sect, which incorporated so much of Taoist doctrines, formulated an elaborate ritual of tea. The monks gathered before the image of Bodhi Dharma and drank tea out of a single bowl with the profound formality of a holy sacrament. It was this Zen ritual which finally developed into the tea ceremony of Japan in the fifteenth century."*

The tea ceremony further developed on the isolated islands of Japan, whereas in Southern China, it was wiped out by the Mongol invasion and later by other foreign rulers. The tea master Juko Murata developed *wabi-cha* in the thirteenth century, a tea ceremony in an informal atmosphere with an emphasis on wabi: the beauty of refined poverty. Another tea master, Sen no Rikyu (1522-1591), further perfected wabi-cha in the sixteenth century. He defined the rules for the movements and laid the foundation for the aesthetics of tea utensils, the tea house and the tea garden. This would further influence Japanese culture. Wabi-cha is the sado that is mainly practised today. The three main schools of tea that still exist today are named Omotesenke, Urasenke, and Mushakojisenke. All three are founded by Rikyu's great-grandchildren.

—

"Sado puts the simple act of drinking a cup of tea on a pedestal", Hirokane says. "It's a celebration of everyday life." The Japanese tea ceremony often comes across as a very serious affair, with its seemingly excessive focus on an uncomfortable sitting position and how to correctly hold a teacup. However, sado is all about cultivating a sense of calmness and reserve while doing something completely ordinary. Nansen, the master of Joshu who would go on to become one of the most renowned Zen masters, once said: "Ordinary mind is the Way".**

Although ordinary, you realise, when observing a tea ceremony, that a theatre of precise movements unfolds before your eyes. In sado, literally every move is predetermined, whether you are holding a cup or setting a ladle aside. "The things we do during the tea ceremony are not any different from our daily lives", says Hirokane. "However, tea masters turned it into a ritual with very strict rules to frame the mindset. These rules may seem quite rigorous but if we were to do things differently, it would look weird. The rules are there to make the movements look natural. Sometimes, the sensei will say to his student: 'Let's just do it the normal way'. Each movement is about taking the shortest and simplest way from point A to point B. Every rule is quite simple. But it's the sum of all the rules that makes it so hard. So it's important to study the rules until they become second nature." Once the movements become part of the intelligence of the body and not the brain, the rules offer a tremendous sense of visual and mental serenity.

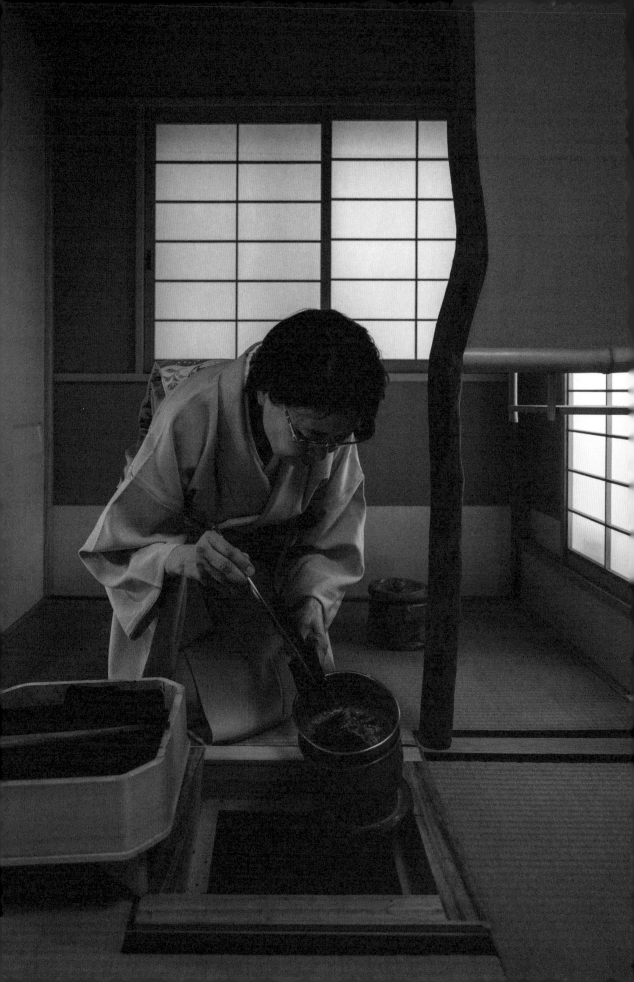

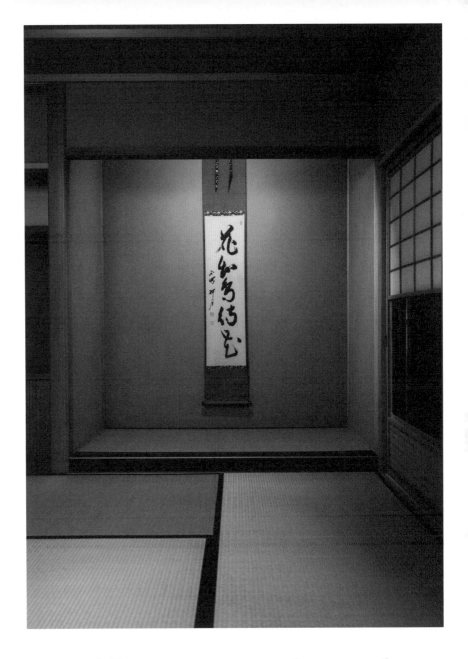

By avoiding movements that stand out, the ego retreats to the background. Every movement should flow as if its beginning and end are unclear.

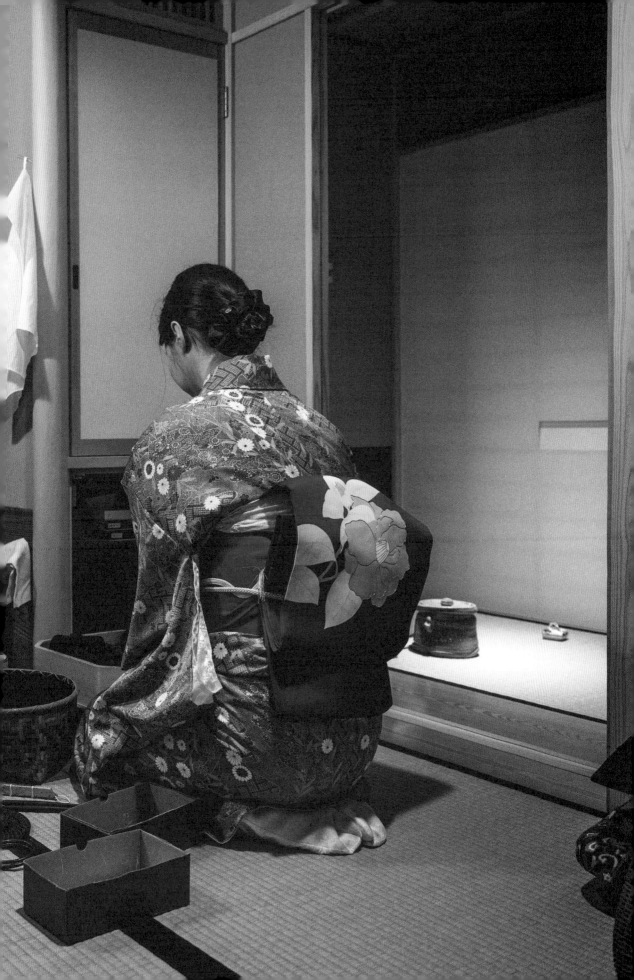

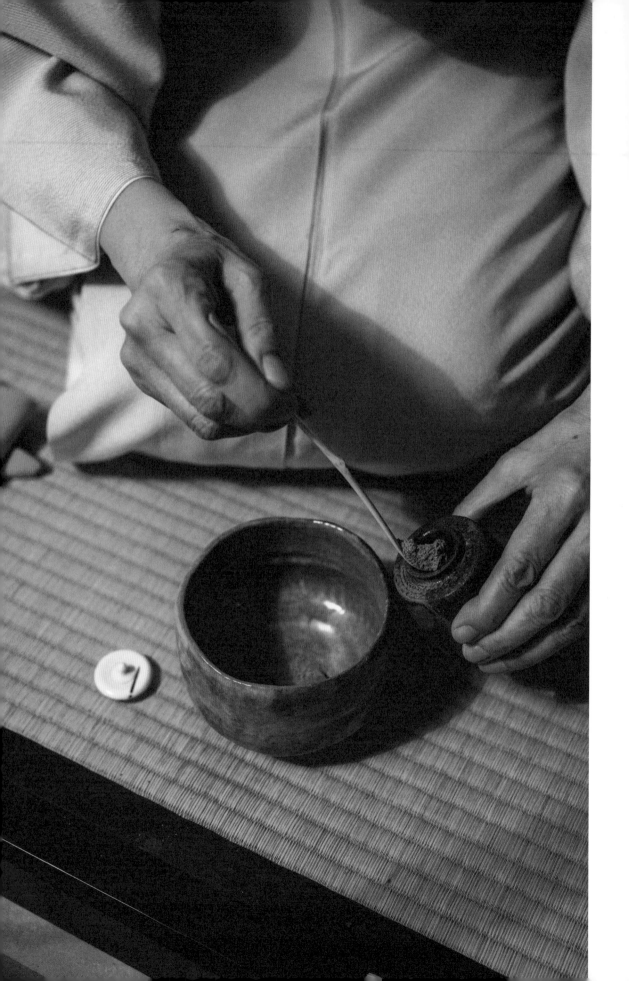

When I asked craftsmen about shosa, most of them referred to the beautiful and pure movements of sado. "I prefer to use the word *otemae*, which means skill", Michiko says. "In my opinion, shosa is a word a grandmother would use. For example: 'Mind your shosa!', *(laughs)*. From the moment you receive the guest to the final farewell, every movement is performed in a very precise way. For me, shosa means creating an impeccable flow of movements out of respect for your guest. It's a matter of perfect hospitality."

By avoiding movements that stand out, the ego retreats to the background. Every movement should flow as if its beginning and end are unclear. Kakuzo Okakura writes: "Not a colour to disturb the tone of the room, not a sound to mar the rhythm of things, not a gesture to obtrude on the harmony, not a word to break the unity of the surroundings, all movements to be performed simply and naturally – such were the aims of the tea ceremony."*

Hirokane: "Sometimes people think that sado and the shosa that comes with it are all about what you're *not* supposed to do. If your intentions are good, then that's ok. You can make mistakes." Sado is not about maintaining a certain etiquette but about honesty. It is not the rule but the purity behind the rule that evokes beauty. "*Yonobi*: the beauty of function. That's what it is." In a sense, sado is like a shosa performance in which the beauty of simple and functional movements, free from any ego, reign supreme.

—

During sado, the guest must also observe some rules. Good shosa is a two-way process. "Think of it as a state of mutual love", Hirokane laughs. "There's a certain tension present between the host and the guest. The guest is not completely at ease, not relaxed after flopping down on his sofa after work. You could compare it to meeting someone you admire." She points to a mutual, deferential behaviour, designed to create a moment where everything is in harmony.

"There's definitely some disruption of the harmony, though", Hirokane laughs. "People forget that drinking the tea is the very last part of a four-hour ceremony. The guests start with a meal during which alcohol is served. An important element is the communication between the guest and the host. For me, shosa is also about how much enjoyable time you can create for others".

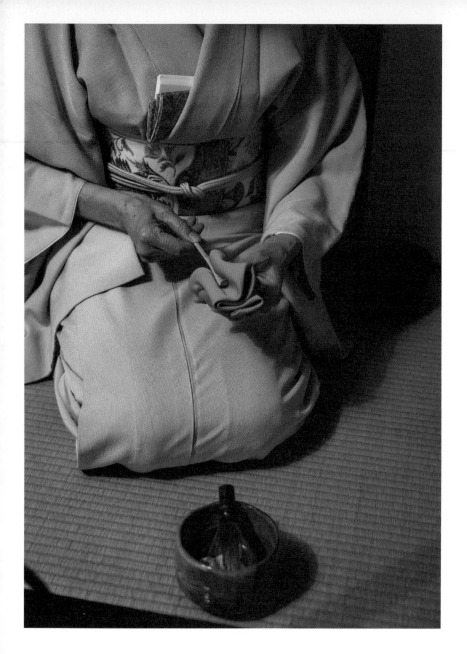

"*Sado* puts the simple act of drinking a cup of tea on a pedestal. It's a celebration of everyday life."

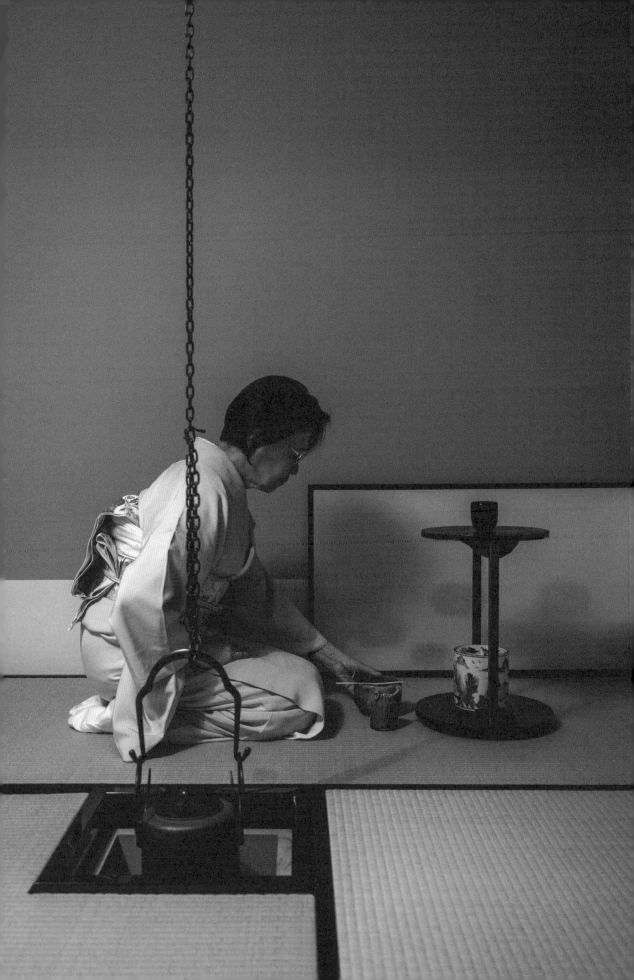

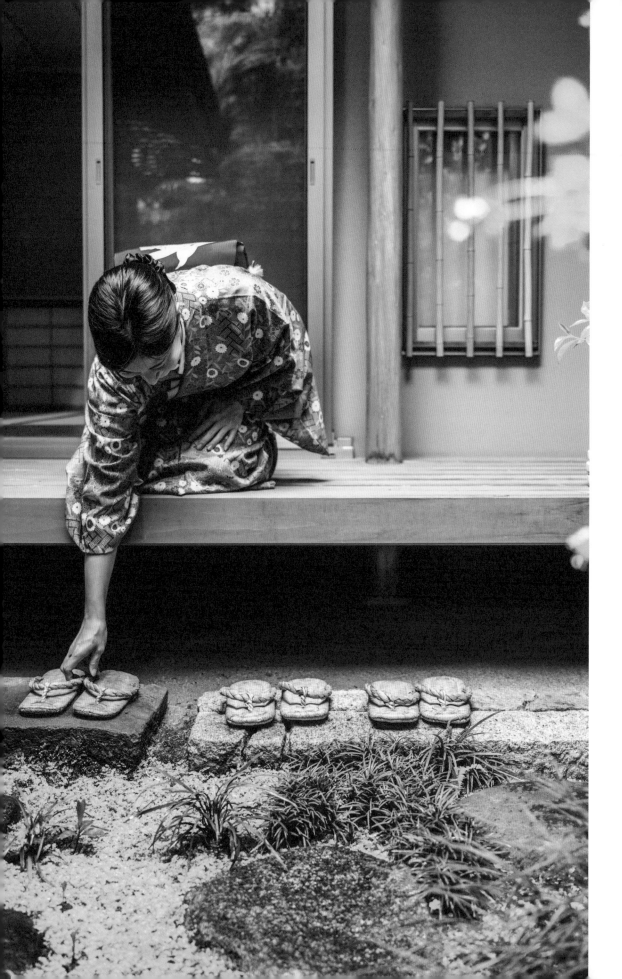

Hirokane serves the photographer and I *koicha*, a thick tea made with high-quality matcha, which she explains is "the espresso variant of tea". Its texture paints the *chawan* or tea bowl an intense green. Although I have no idea what the right way is to hold the cup, she does not seem to mind. "Many Japanese don't know either", she assures me, ever the perfect host. After the tea, she sits in a bowed position. "This is usually the time we chat", she says. It is customary for guests to show an interest in the beauty of the tea utensils. They have all been meticulously chosen and vary depending on the season, time and mood. The same goes for the message on the scroll in the *tokonoma*, the alcove. Sado is a reminder that every little detail in life has meaning and should be considered accordingly.

From The Book of Tea *by Kakuzo Okakura (1906). Translated and published as an ebook by Matthew, Gabrielle Harbowy and David Widger for Project Gutenberg.*
** From* Radical Zen, The Sayings of Joshu. *Translated by Yoel Hoffmann for Autumn Press.*

True nature

やまなみ工房

Shiga Prefecture surrounds Japan's largest lake, Biwa, which is just a stone's throw from Kyoto. Despite its expansive blue surface, Biwa is not the most obvious travel destination. Many small towns around Biwa are not particularly picturesque, and finding a scenic view of the lake can be somewhat challenging. One place stands out: Omi-Hachiman, an ancient trading hub with its beautifully renovated *machiya* – traditional townhouses – and a picturesque canal that runs through the centre. You can sit on an ancient staircase along the canal and gaze at the traditional trading boats that float by, which nowadays carry visitors instead of merchandise.

As I sit on the stone steps, I am captivated by a heron on the canal bank. I find its posture and poise fascinating. Occasionally, it stretches its neck and then returns to that same position, motionless. Whatever stance it assumes, it always looks flawless. About half an hour later, the heron suddenly plunges its beak into the water, grabbing a fish, after which it flies nimbly to the other side of the canal, where it proceeds to swallow the fish in one fell swoop. All I can think is: perfect shosa. There is much to learn from animals.

The reason I am staying in Shiga is not Lake Biwa but Atelier Yamanami. The next day, I find myself on a local train heading south through a Japanese landscape of rice fields. Upon our arrival at Konan Station, the photographer and I notice a troubled man darting out of the train and rushing down the stairs as if his life depended on it. Outside the station, where two vans are parked, the troubled man boards one, and we take the other. It turns out we are headed to the same place.

"This is a book about the work of Yuichiro Ukai, which was shown in New York in late 2023", says director Masato Yamashita as we sip tea in the new restaurant building at Atelier Yamanami. The day centre facilitates creative expression for people with severe mental or physical disabilities. "Currently, there's an exhibition in Belgium featuring ten Japanese artists with mental disabilities. Two of them are from here. We participate in about two to three exhibitions each year."

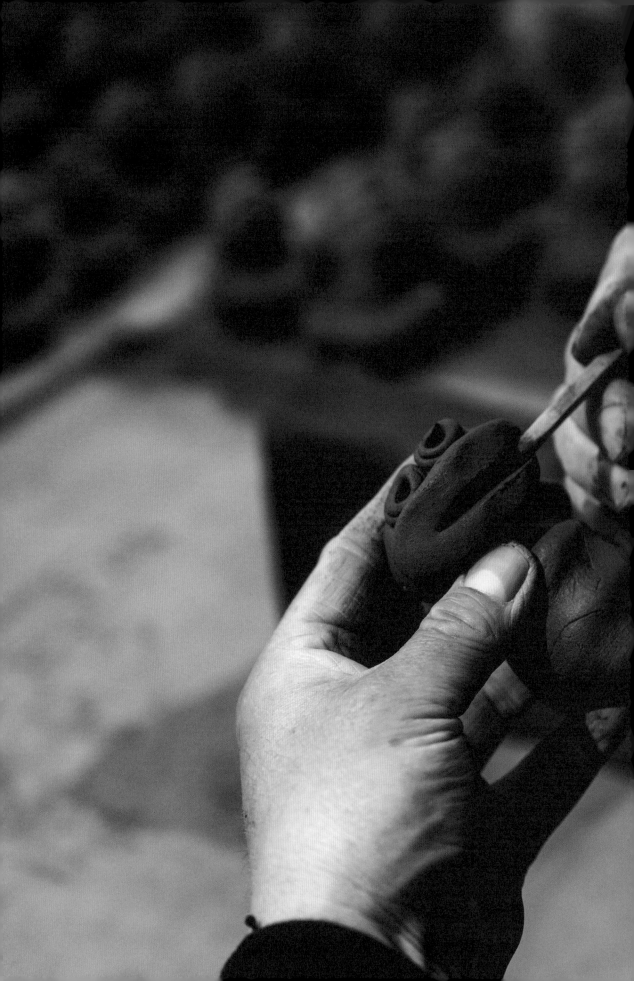

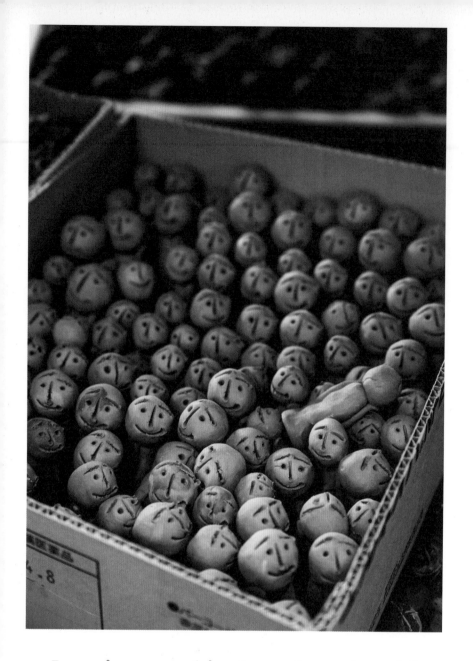

Leaning over his sheet, he raises his right hand in the air, slaps the table, and then repeats this action. He then draws a miniature face. This ritual is repeated all day long.

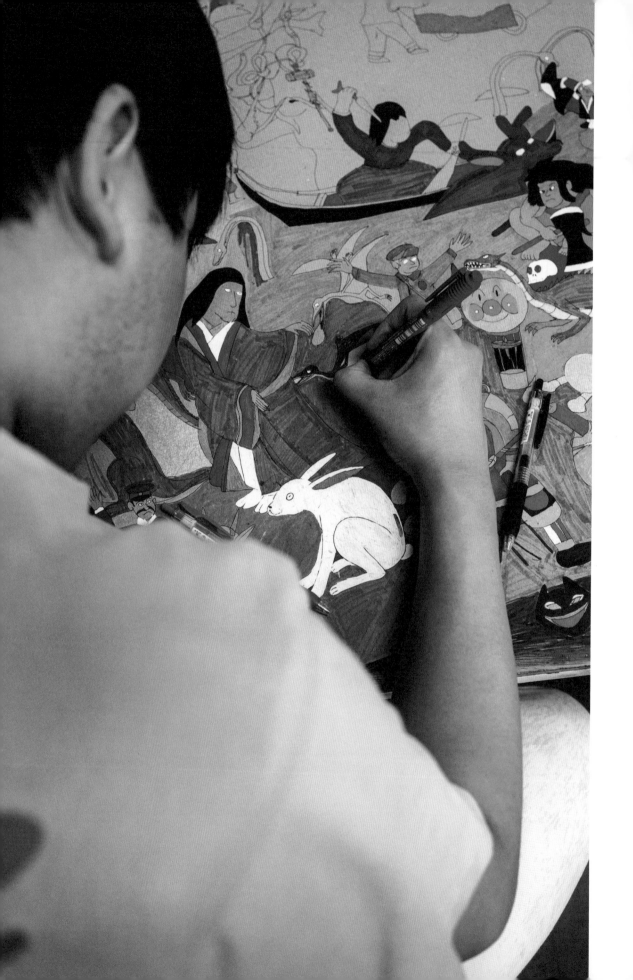

It was through Yuichiro Ukai's work that I came to know Atelier Yamanami. Ukai paints grotesque allegories reminiscent of Hieronymus Bosch. Hundreds of colourful figures are depicted in a dialogue with each other. The figures are inspired by ancient Japan and pop culture. Samurai meet dinosaurs and Pokémon. Perfectly composed chaos.

During a tour where the staff of twenty take the time to introduce us to all 97 residents, we meet other talented artists like Hideaki Yoshikawa, who draws abstract forms consisting of a refined texture of tiny dots. These dots are not random. When asked what he is drawing, he replies in a funny, shrill voice: "*me, me, hana, kuchi*" – eye, eye, nose, mouth. His organic shapes are constructed from thousands and thousands of tiny faces. His work process is equally fascinating. Leaning over his sheet, he raises his right hand in the air, slaps the table, and then repeats this action. He then draws a miniature face. This ritual is repeated all day long.

None of the residents have ever received any formal training. "This is a day centre for individuals aged eighteen and up, with a mental capacity ranging from one to seven years", explains Yamashita. "Some are deaf or partially paralysed. The atelier was founded in 1986 by my father, with three residents performing simple tasks for a meagre salary of around three thousand yen per month (twenty euros). It wasn't great, but at least they had a place outside their homes. At one point, a resident named Keigo Mitsu began painting on small scraps of paper in between work. I noticed how happy this made him. That's when I began to question our labour practices and changed course. It's not that I wanted to integrate art into our operations. I just wanted to make them smile."

I am fascinated by Kasumi Kamae. She creates tiny, furry-looking monsters from clay that seem to have escaped from the realm of the *yokai* – Japanese demons and ghosts. Watching her work is a delight. Each strand of hair is made from a small piece of clay that is rolled between her fingers and then applied to the base. "Each sculpture is a representation of Yamashita", explains a staff member. Suddenly, I spot the man I saw rushing down the stairs at the station walking down the stairs of the workshop with the same intensity. Takuya Tamura draws portraits composed of a mosaic of rectangular colour blocks. His work has also been exhibited.

—

"Although all 97 individuals have their own craft or discipline, they don't see themselves as artists", Yamashita explains. "They don't seek fame. They arrive here in the morning, start working at 10.30 am, and finish at 3 pm." Some are good, others make less appealing work but at Yamanami, they do not care how their creations are perceived by the outside world.

The last artist I meet is Yuichiro Ukai, who I found working in a studio with ten other residents. It quickly becomes apparent how specific and precise everyone's work is. "Ukai has severe autism, and his verbal communication is very limited", Yamashita explains. "He memorises and expresses

what he sees on YouTube or in magazines through paint and markers. He starts by sketching out everything, after which he colours it in. He only uses the colours he has in mind. Initially, we gave him twelve markers. Then, we noticed that many areas were left blank. When we gave him more colours, he resumed work. Now, he has about two hundred different colours. But if he can't find the right colour, he won't colour in the shape."

"Besides drawing, he also enjoys cleaning toilets," Yamashita adds. "If he's not allowed to clean toilets, he loses interest in doing things like painting." Together with Ukai and several other residents, we head towards a public toilet. Upon arrival, Ukai immediately gets to work. He is visibly happy. It reminds me of Wim Wenders's recent film, *Perfect Days*, in which the protagonist's job is to clean toilets, and he is okay with it. Ukai, like the film, reminds us that we let society's ideas cloud our judgement. Why can't cleaning a toilet be enjoyable? Are the movements that difficult?

The residents of Yamanami have the same purity as the heron I saw the previous day. While the people outside Yamanami's walls spend much of their time questioning themselves, Ukai and the other residents dedicate their time to their personal passions without any doubt in their minds. "What we can learn from them is that we shouldn't worry about what others think of us," says Yamashita. "Be consistent about being you."

The creations that are made at this day centre are categorised as 'outsider art' or 'art brut'. Although Yamashita is not remotely bothered by these titles, it speaks volumes about society's view of these individuals. They are outsiders, not people within society, let alone the art world. These individuals create art without any intention to do so. While the art world may see this as inferior, I find their expression to be less forced and purer, more genuine. It is in their nature to create art.

In the restaurant's entrance hall, there are hundreds of small ceramic figurines that resemble anthropomorphic frogs. These tiny sculptures have become a mascot for Yamanami. They are the work of Masami Yamagiwa. "He has already made thousands of these sculptures. Each figurine takes less than a minute to make. He says they're self-portraits. Yamagiwa works for just fifteen minutes a day and then wanders around, picking up litter." I ask the staff if I can watch him work. A few moments later, a slightly grumpy man storms into the atelier, panting and humming. He grabs a lump of clay and takes a seat at his table. In a sharp, monotonous voice, he formally announces that he is about to start working. Then he creates one figurine after another with the skilful hands of a craftsman.

Yamagiwa and all the other residents evoke images of a beautiful shosa. What is Yamashita's take on this? "Shosa is about attitude and how you move. We tend to align our attitude and movements with other people's opinions. These people don't. All 97 residents have 97 different shosa. You could say that shosa is actually very important for them." They do not have a filter. With these individuals, inside and outside are practically identical. The shosa *is* the person. The action *is* their being.

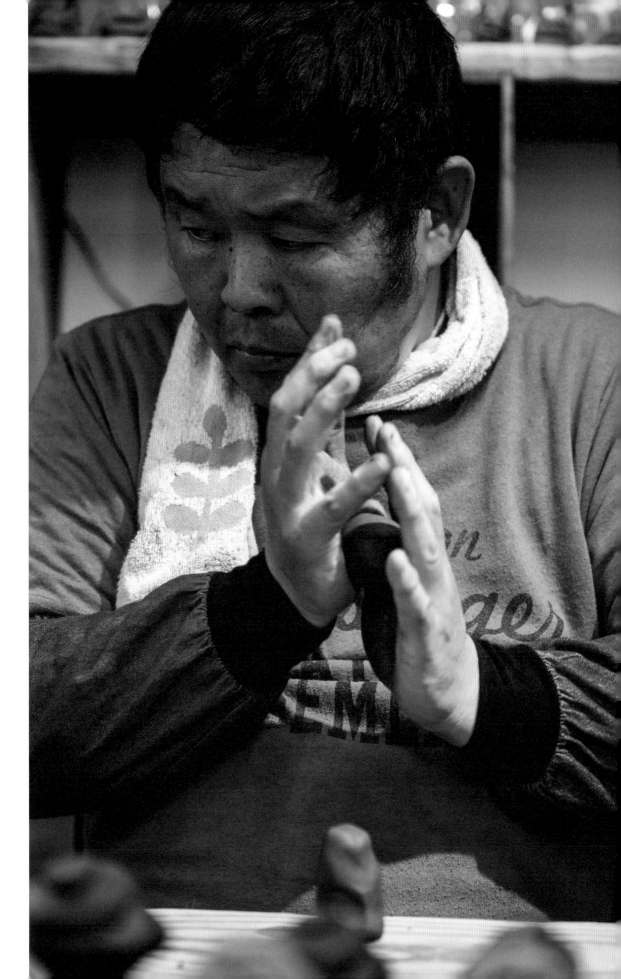

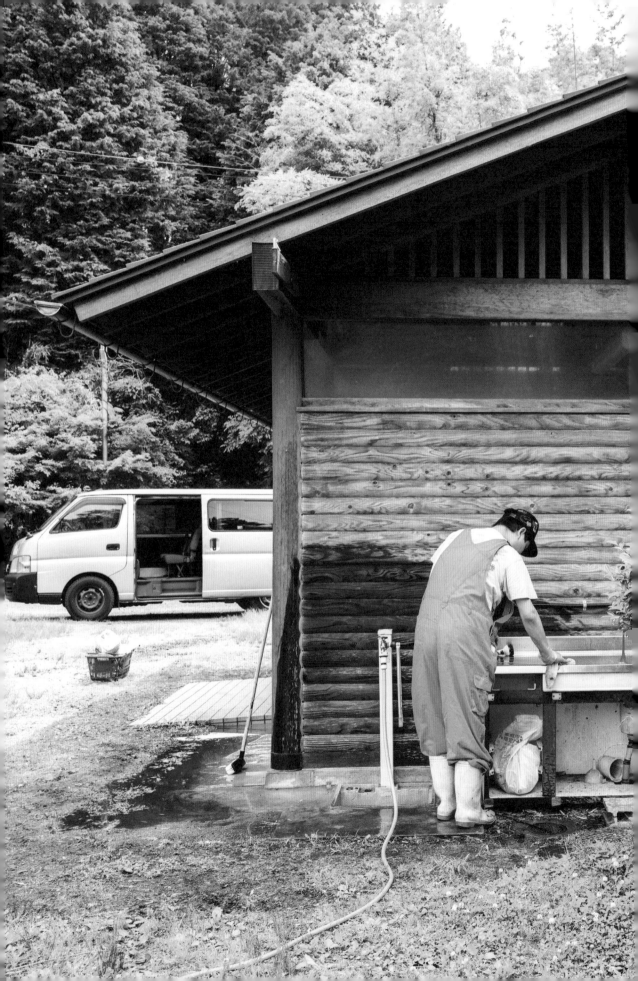

Inking the inner self

Kobaien
Akinori Watanabe
Kiho Shigihara
Shodo
Nara and Sendai

古梅園
渡邊章紀
鴫原希歩

Nara used to be the capital of Japan for a brief time in history (710-794) before the emperor moved his household to Kyoto. Today, the city mainly offers tourist attractions from these bygone days. The many Buddhist temples and Shinto shrines, with Todai-ji and its fifteen-metre-tall bronze *daibutsu* (Buddha statue) as the pièce de résistance, are quite impressive. The parks near the temples are inhabited by herds of deer, a sacred animal in Shintoism, the native Japanese religion. In summer, the area around the temples overflows with tourists armed with a bag of deer biscuits, eager for a selfie. Sometimes, it seems like the deer draw more attention than the actual temples.

I have stood in front of the Todai-ji daibutsu before, and the experience was jaw-dropping. Today, I get the same feeling while standing at the dark entrance of Kobaien, which is probably Japan's oldest ink factory, just a stone's throw from the sightseeing crowds. Japanese ink, or *sumi*, has been made here in the same traditional way since 1577. As light and shadow cross daggers, I notice an old train track that has been carved into the stone floor, which draws my gaze towards the courtyard where a plum tree grows. The company owes its name to this tree – it means old plum tree garden. "We still use this track", says the owner, who prefers to remain anonymous but is the sixteenth generation at the helm of the company. The ink sticks are transported from the back to the front of the building in an old wooden cart reminiscent of the action scenes in adventure films.

Sumi ink is mainly used for Japanese calligraphy or *shodo*. "Many people think ink is always liquid, but the highest quality sumi comes in the form of a stick that you have to grind", the owner explains. At Kobaien, the sumi consists of nothing more than soot and natural glue. In the courtyard, it is easy to tell where the soot rooms are located by the large and smoky shadows around the doors. Inside, the ambience is dark and hot. The walls are lined with rows of burning candles made from natural oils derived from camellia, sesame, safflower, radish, paulownia and rapeseed. Each oil produces a slightly different shade of black ink. A ceramic lid atop each candle is used to harvest the soot from the flame. "Every twenty minutes, a craftsman rotates the lid 45 degrees. He also regularly scrapes off the soot with a brush." The surroundings reduce me to silence.

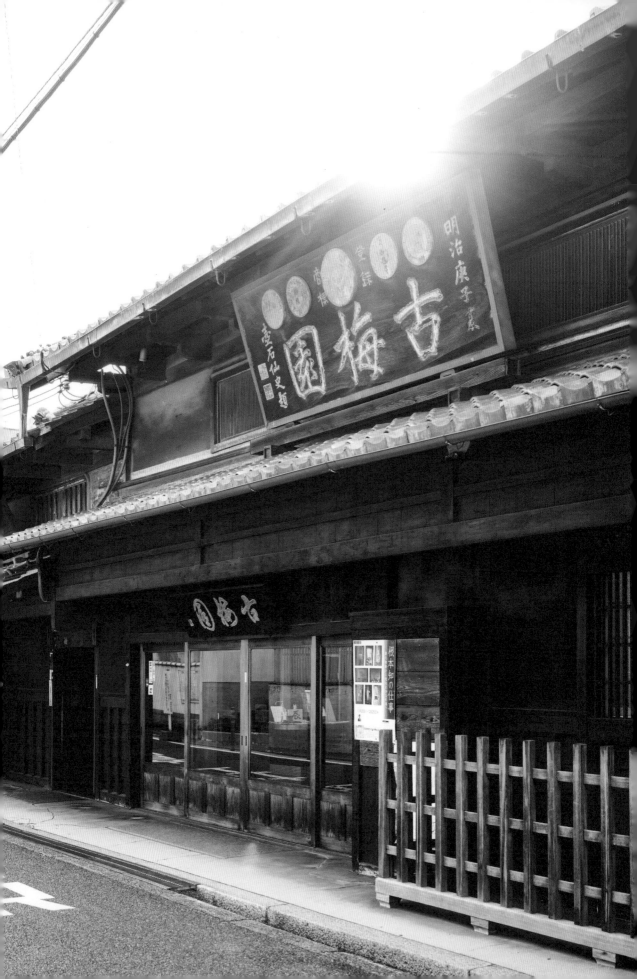

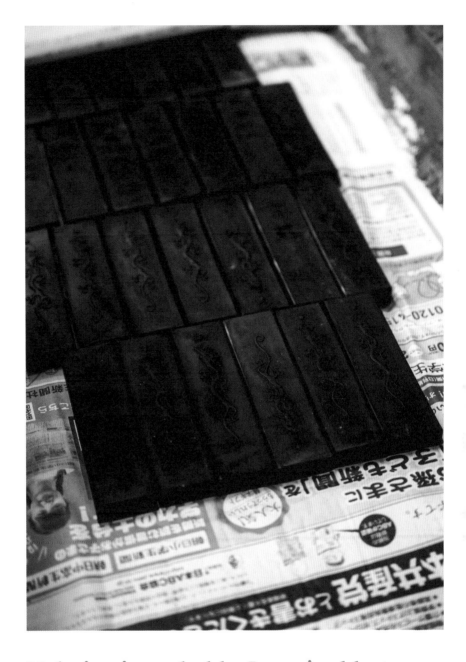

Kobaien is probably Japan's oldest ink factory. Japanese ink, or *sumi*, has been made here in the same traditional way since 1577.

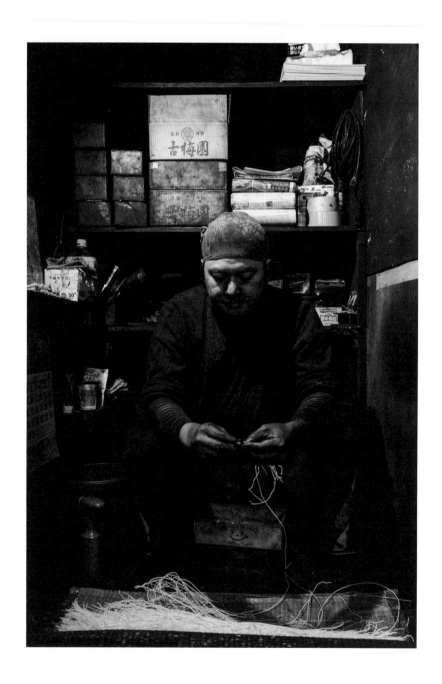

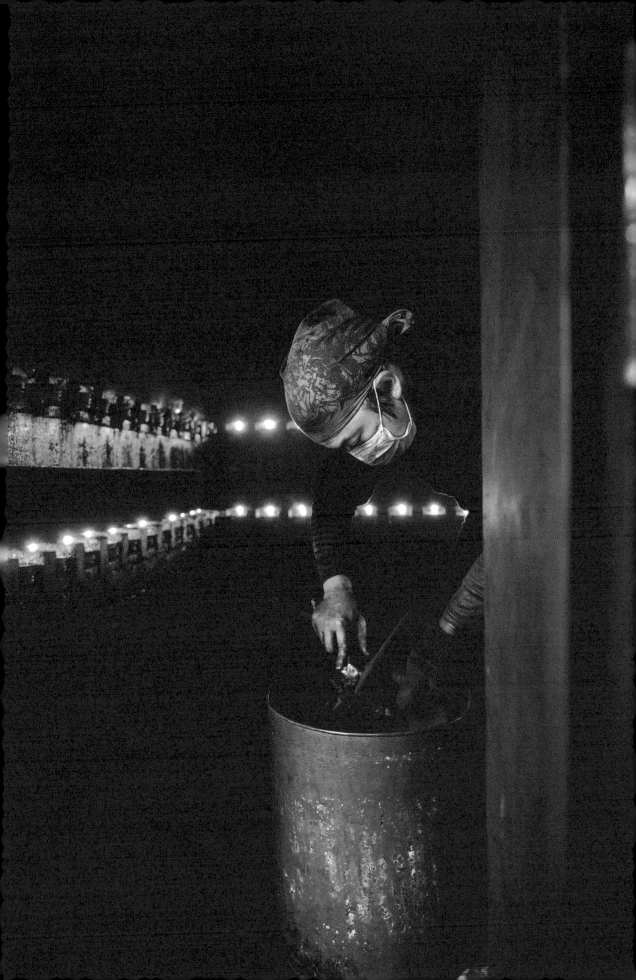

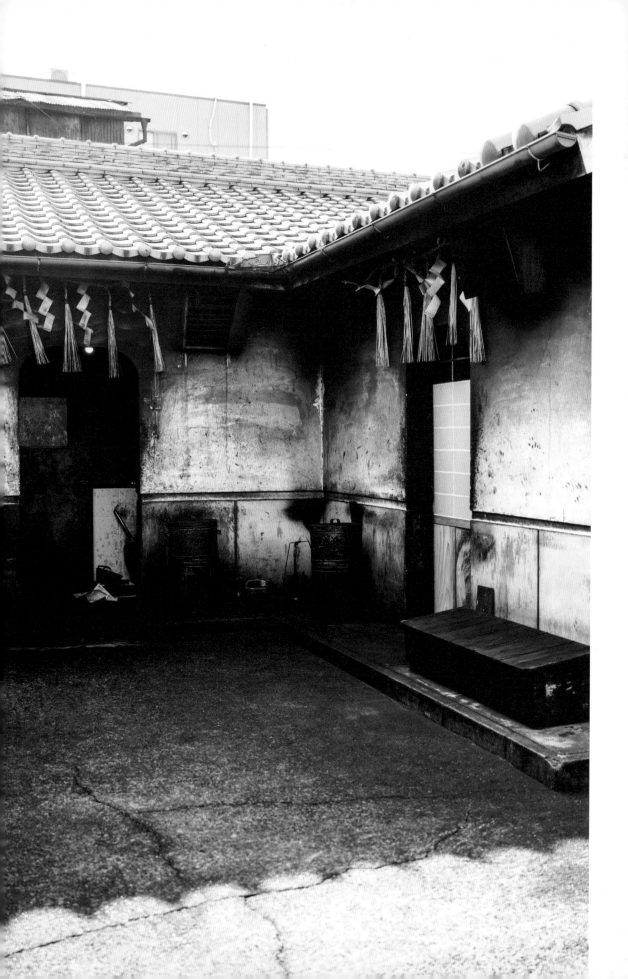

When a craftsman enters the room, the factory owner apologises to him for being in his way, displaying unprecedented respect for the employee. "I know he's a quiet person. Besides, I don't want to break the silence. The makers must be able to concentrate."

The day's harvest is a handful of soot.

In another room, various fossil-like lumps of gelatin, a natural binder, lie on wooden shelves. "Gelatin is made from animal hides. This is cow, horse, deer, and this one here is donkey. These days, gelatin from donkeys is very difficult to obtain. The lump I'm holding is already two hundred years old", the owner explains.

The ink is made only in winter because once the gelatin is liquidised with hot water, the higher temperatures during the other seasons may be detrimental to its quality. To make the ink even more pleasant to use, various natural fragrances are added, such as camphor and ambergris, an extremely rare excretion of sperm whales which is highly prized in the perfume world.

As we walk through the factory, I get to see the small wooden shacks where a craftsman kneads the ink with his feet. Another craftsman uses an old and weathered mould made of pear wood to press the ink dough into a straight shape. I notice that the shadows here in Kobaien are pitch black as if they were painted with ink. Every object, every room, and every activity exudes a sense of poetry. The owner agrees, noticeably still moved by the beauty of the company grounds.

The drying room is located at the rear, where the train track ends. The sumi sticks are placed in large wooden boxes which contain moist ashes. Every day, the boxes are replenished with ashes that are less moist to gradually dehydrate the sumi. This process takes about a week for a small stick and about 30 to 40 days for a large stick. After this drying process, about 70% of the moisture has evaporated, and the sticks are transferred to another room to dry further. This process takes anything from a month to six months. Finally, the sumi sticks are glazed, polished with a big seashell, dried again and decorated with gold powder, silver powder and pigment. "This is a very inefficient way of working", the owner admits at the end of the tour. This company prizes beauty above all else. It is an anachronism in today's consumer culture.

When I ask the owner what shosa means to Kobaien, silence ensues. Surely, the choice to make a product in the traditional way implies a sensitivity to this word, with the handwork being just as important as the product itself. Kobaien preserves the beauty of the old manufacturing process: the movements, the atmosphere. "For an explanation of shosa, you should really ask someone who doesn't make the ink but uses it."

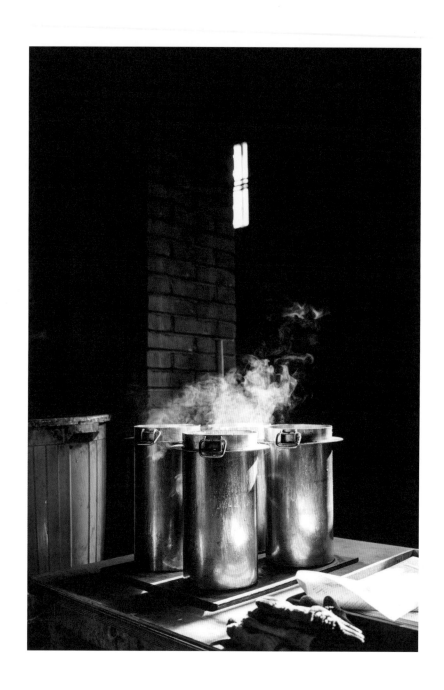

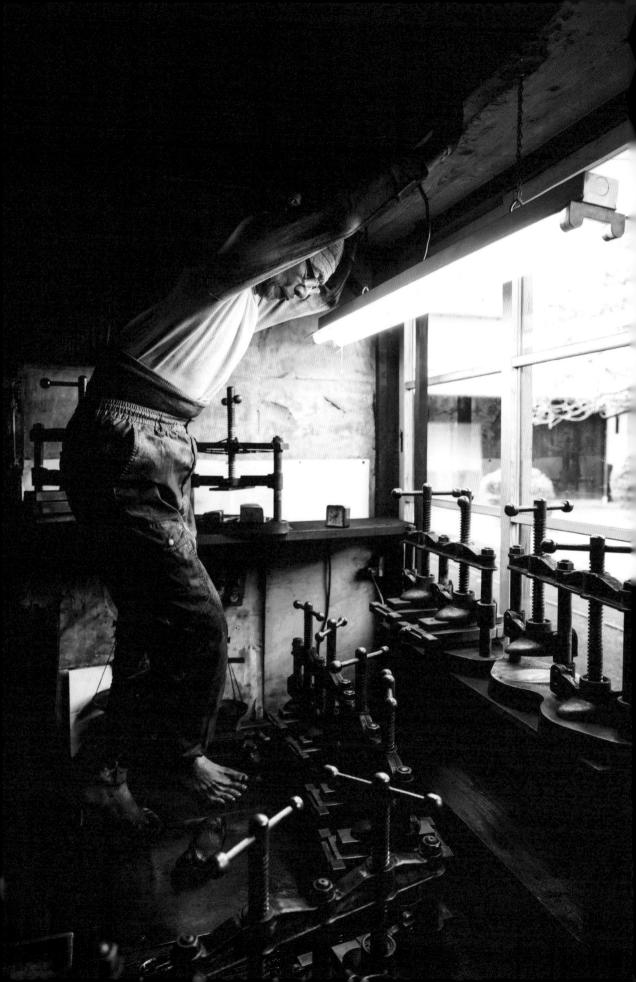

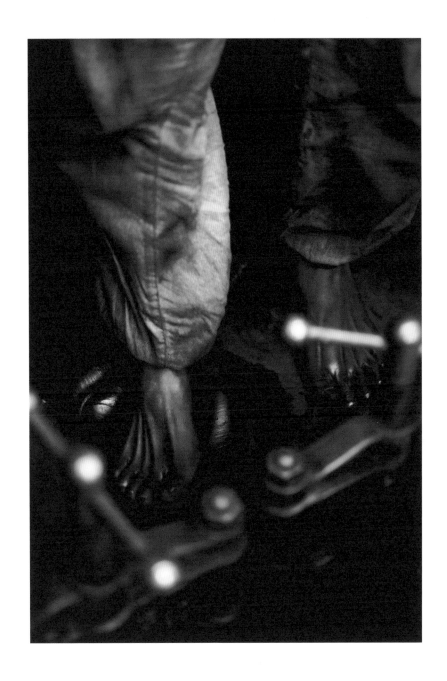

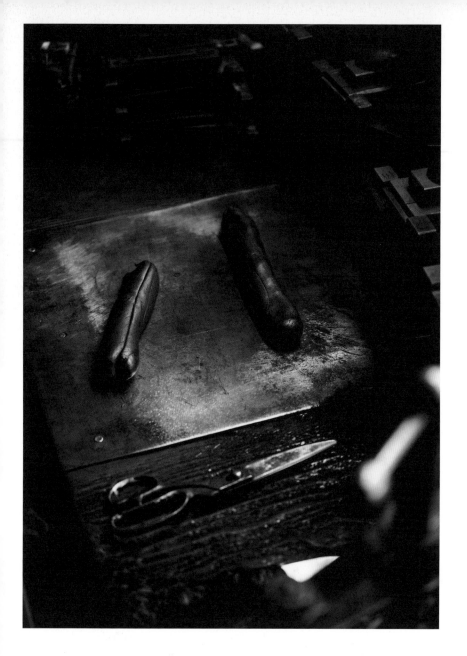

Every object, every room, and every activity exudes a sense of poetry. The owner agrees, noticeably still moved by the beauty of the company grounds.

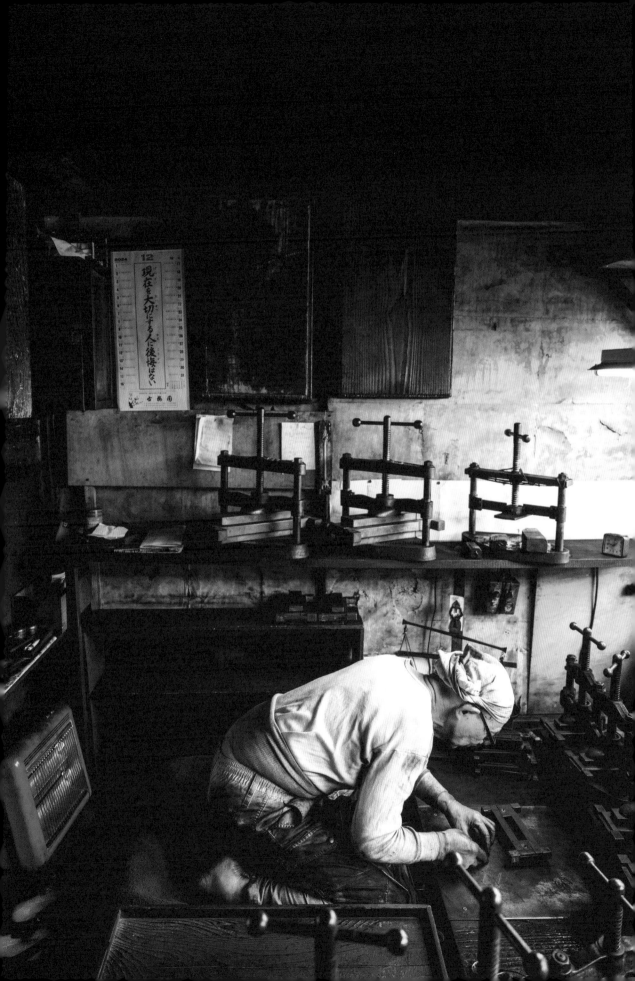

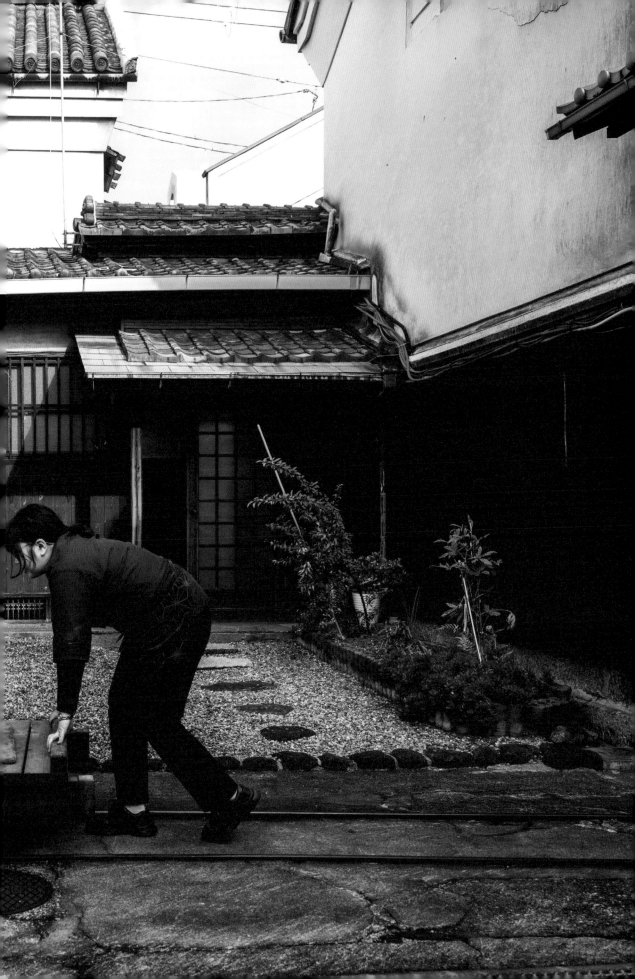

"In Japanese culture, shosa is an important concept", says Akinori Watanabe. He is the sensei of the Japanese calligraphy or shodo club at the Sendai Ikuei Gakuen high school. Sendai is the largest city in Tohoku, the northeastern part of Honshu, the main island of Japan. Nine hundred kilometres separate Kobaien from Sendai.

The reason I travel north is because Sendai Ikuei Gakuen high school has one of the best shodo clubs in the country. In 2024, they won first prize in the national shodo competition for the third year in a row. The shodo club is an after-school activity. In Japan, almost every student participates in such activities. I head to the large Tagajo campus, where I find the shodo club room in a separate building designated for after-school activities. Thirty club members practice shodo here daily. The atmosphere is remarkably relaxed. At one of the many low tables, a girl works alone on her shodo while others practice the upcoming shodo performance accompanied by *taiko* drummers.

Watanabe shows me a video of such a performance. I see a group of energetic girls painting with brushes the size of brooms on a large sheet of paper lying on the floor. Choreography, rousing music, it's all there. At the end, the sheet of paper is lifted to display the result. Almost all the members of the shodo club are girls. Boys tend to like more challenging activities, Watanabe suspects. Above us, the ceiling rumbles, and we hear shouting. *Kendo*, or Japanese fencing.

According to Watanabe, who has been practising shodo since he was eight years old and who founded this club in 1990, shosa means a lot, especially in shodo. "In Japanese culture, often it's not just about the end product but also about how you arrive at that result", he explains as we sit down at a low table. "With sushi, for example, it's not just about the taste but also about how you cut the fish. The beauty of the movement during the manufacturing process and the awareness that goes along with it are very important. I believe that's unique to Japanese culture."

"Essentially, shosa is all about how you move", he continues. "A perfect shosa means moving without any wasted movement. Only a trained person can do that. Sometimes, the result of a Japanese traditional art discipline might look quite simple, but it requires years of experience. This is also the case for shodo. It might take twenty years to gain perfect control of your brush – but therein lies the beauty. The goal is to express your personality with the tip of your brush. Drawing a simple line is easy, but drawing a line with which you express yourself is much more difficult. Everything the person has experienced in their lifetime should be encapsulated in that one line, from their personality to their physical condition." Shosa is very important in this process. "Shodo and shosa are inextricably linked. The brush is very soft. The line changes with the slightest change in movement." Shodo is almost like a direct translation of shosa into art.

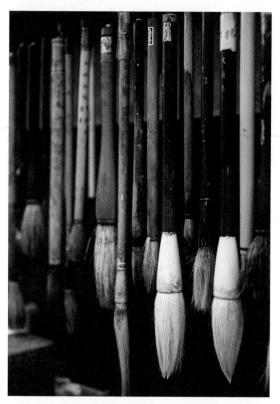
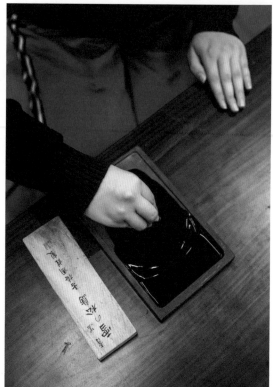
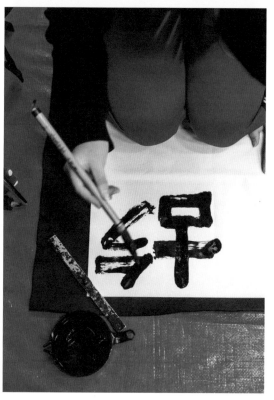
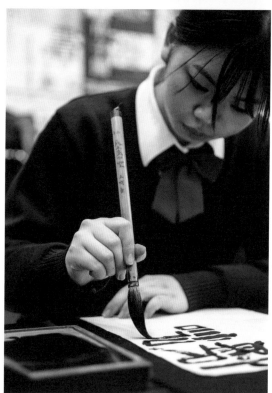

As I look around the classroom, I get the impression that shodo is very popular among young people, but this is misleading. Although Japanese children must take calligraphy lessons in grammar school, their interest usually wanes with age. This was not the case for these students. I speak with Kiho Shigihara, who is eighteen years old and the captain of the team. She started practising shodo when she was just eight years old. She turned out to be very skilled at reproducing old texts and now hopes to develop an expressive style like the great masters of the past. Does a young person like Kiho still know the word shosa? "I know the word. We use it in shodo but never outside of it. Sometimes, after practising a performance, we say, for instance: 'Our shosa was not in sync.'" For her, shosa means the movement of the hand and the body. "Shodo is all about establishing a connection between your body and soul and expressing yourself in the purest way possible," she says. "Shosa is very important. Your body and brush must move exactly as your inner self desires."

Shosa
of the sword

天真正伝香取
神道流

A man in a black kimono sits in a vast, empty space. He draws his sword, slicing horizontally through the air, then vertically. This is followed by a moment of stillness. He flicks the blade as he rises, standing tall. With a straight back and a fluid motion, he sheathes his sword.

Above is a description of an instructional video of the Japanese discipline of *iaido*, or the art of drawing the sword. The word consists of three characters: 居合道, meaning 'being', 'adaptation' and 'way'. Although in iaido the exercise consists of drawing a sword, slicing through the air and then sheathing it, its practice is mainly designed to maintain a state of constant readiness for the unexpected. In 1957, the New York poet Frank O'Hara wrote a poem titled *Meditations in an Emergency.* To me, this perfectly describes iaido. Staying alert in the face of sudden chaos.

For several years now, I have been fascinated by iaido, all the more so because it is such a silent and meditative martial art. Despite wielding a blunt sword called an *iaito* – masters tend to use a real sword called *shinken* – the practitioner has only one opponent: himself. Iaido consists of nothing more than performing *kata*, a series of prescribed movements. The seemingly basic but highly efficient sword blows are practised over and over again until perfection is achieved. Unlike in *kendo* (Japanese fencing), there are no duels.

During my research into shosa, I could not stop thinking about iaido. I noticed significant similarities in attitude and respect between the iaido practitioner and, for instance, a potter. The repetition, the creation of perfectly efficient, precise movements. The focus.

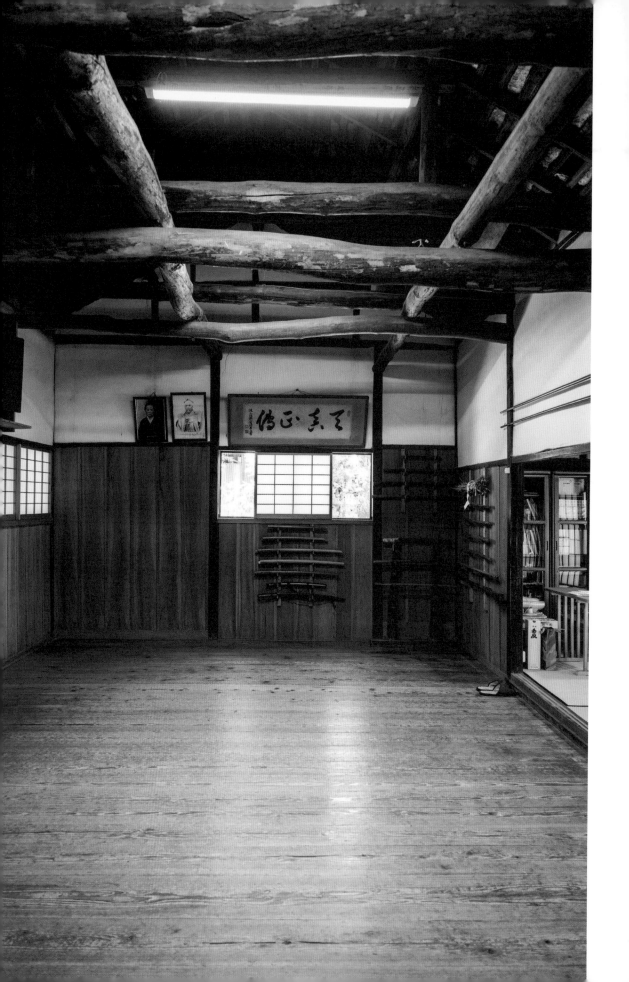

I am in Chiba Prefecture, a relatively unknown region to the east of Tokyo. Overseas tourists only vaguely know the prefecture because Tokyo Narita Airport is located here. A lesser-known landmark of this prefecture is Japan's oldest sword school. Tenshinshoden Katori Shinto-Ryu, or the school of Katori shrine, was founded in the mid-15th century by a man named Ienao Iizasa. The founder is said to have prayed at this shrine for a thousand days from the age of sixty, purifying his mind through relentless martial arts training. Supposedly, he received a sacred scroll from the shrine's deity and went on to establish his school.

While many sword schools disappeared during the Edo period because this was a time of peace, this school continued to thrive. Today, it is run by the twentieth generation of the Iizasa family. Yasusada Iizasa is 87 years old and is assisted by his successor and son-in-law, Kota Iizasa.

Katori Shinto-Ryu is a complete martial arts school where students learn to wield a dazzling array of weapons. The most important one is still the sword, however. Here they teach *iaijutsu* – the word used in older sword schools, as opposed to iaido, but the practice is the same – and *kenjutsu*, practising kata in pairs with wooden swords called *bokken*.

There are video documentaries from the 1980s online, featuring the small, six-hundred-year-old dojo (training hall) of the school with its weathered wooden plank flooring and chiaroscuro lighting. Sweaty men in kimono fill the space, their wooden swords clashing at full speed. Upon joining, students sign a paper contract called 'The Respectful Oath to the Supreme Deities' with a drop of their own blood.

"With this blood oath, you swear not to pass on the techniques to others; not to use the techniques on others; not to visit any 'bad places', and not to fight with people from other schools", explains Shigetoshi Kyoso. Since 2017, he has taken on the role of *shihan* or master trainer, following in the footsteps of his father, Otake Risuke. However, on the day of our visit, we do not find ourselves in the poetic dojo with the chiaroscuro lighting. Instead, we have come to the sports centre where members of Katori Shinto-Ryu gather in the evening to practice.

"During the pandemic, we needed more space, so the school moved to a gym", Kyoso explains. This decision reflects the master's pragmatism. However, the most significant difference with the past is not the location but the teaching method. "My father didn't teach," he says. "You had to learn purely by observing other students, which is difficult since the techniques are quite complex. I teach every skill in detail, and my students can ask me anything. My father grew up in the Showa era. Today we do things differently."

Kyoso never received a single instruction from his father. In fact, his father advised him to learn *kyudo* or archery on the ranch where he grew up among horses. As a result, Kyoso learned everything on his own through observation. When he finally participated in his first lessons at the age of fifteen, he already knew how to do it.

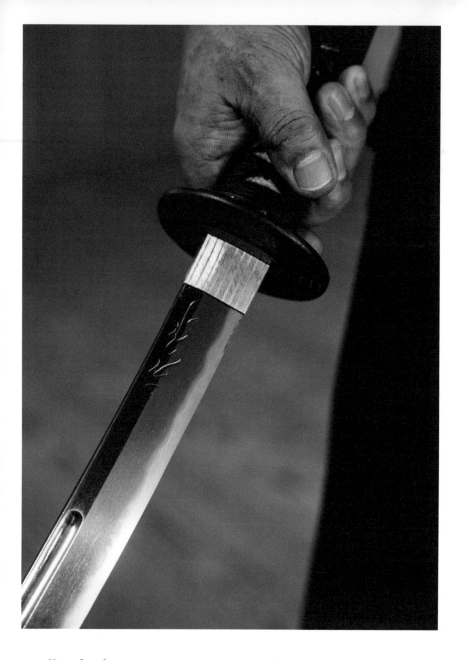

"It is important to make every movement as efficient as possible and to eliminate anything unnecessary. Your opponent can detect your intentions from even the slightest movement. Show no movement and no rhythm."

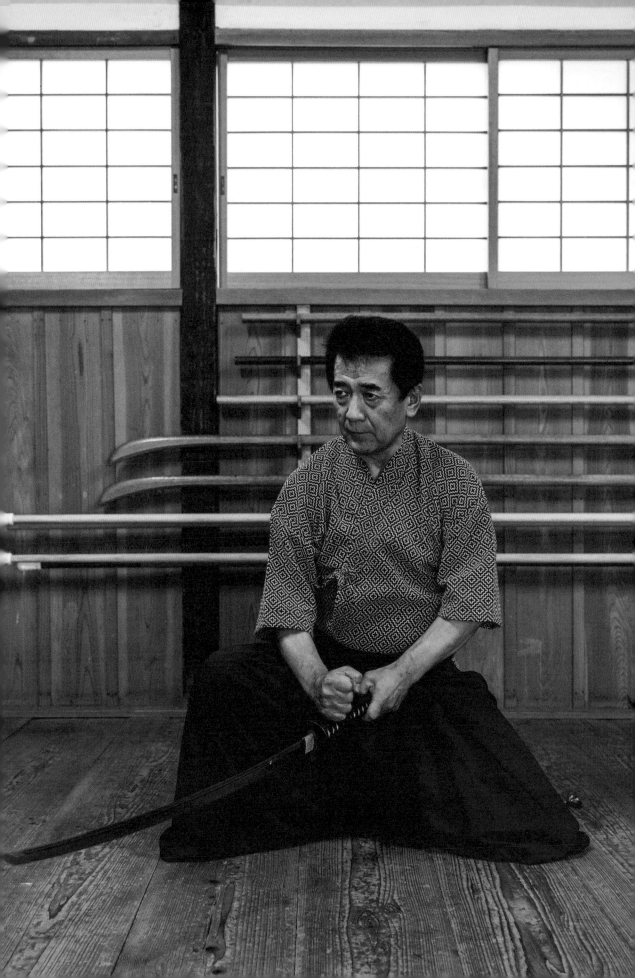

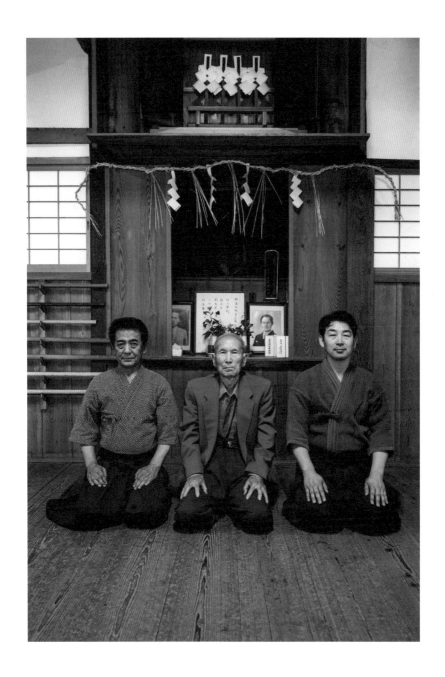

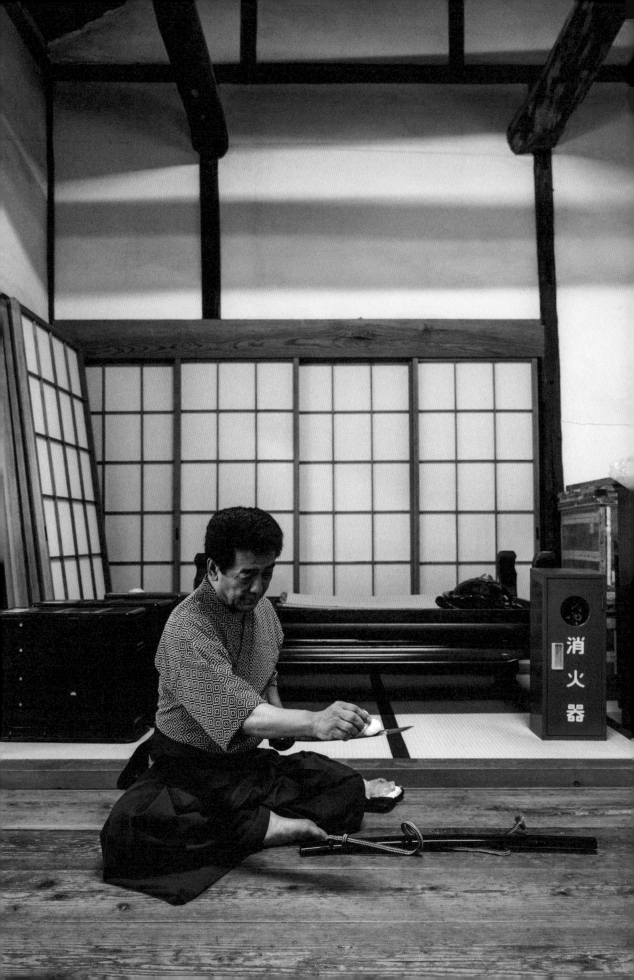

Eight students walk into the sports centre. They are largely silent as they change into their traditional attire at the edge of the hall, after which their iaijutsu begins. After some practice, the students pick up their wooden swords for kenjutsu. "There are only four kata, meaning you have to learn eight: four as the attacker and four as the defender," Kyoso explains. "But we also teach many other weapons." We see a wooden version of the *naginata*, a staff with a curved sword on top, being used.

"It is important to make every movement as efficient as possible and to eliminate anything unnecessary," says Kyoso as we look on. "Your opponent can detect your intentions from even the slightest movement. Show no movement and no rhythm." During our interview, Kyoso does precisely that. He reveals nothing. When I mention the similarities with shosa, he responds, "This word has a very broad scope." Later, he adds: "The first thing you learn here is to be polite and respectful to your opponent. Otherwise, kenjutsu would just be violence."

After the interview, as I head back to Tokyo on a local train, I think about the interview, which was far too short and conclude that I had arrived at the school with many poetic clichés about martial arts. Kyoso eliminated every one of them, simply and efficiently. At first, I suspected him of being stubborn. Then I realised it was I who was stubborn. I had come to him to confirm a preconception that I had. He refused to take the bait.

—

The day after our interview, the photographer and I make the two-hour journey by train again from Tokyo to Katori, this time to visit and photograph the dojo. From the outside, it is nothing more than a small traditional shack tucked away behind a freestanding house. Once inside, we discover an interior made of weathered wood, adding to the serene atmosphere. There is also a small shrine to honour the ancestors of the Iizasa family.

The story of this school turns out to be spectacular and humble in equal measure. To insiders, it is a world-famous institution; to many others, it is nothing more than a shack. "You know, we do take a blood oath to pledge secrecy", Kota Iizasa, the young successor, says with a smile. "We still receive foreign applications on a weekly basis. Many people are interested, but only a few stay the course. Is it appropriate for a martial art to become famous? Ultimately, we are teaching our students ways to kill people."

During the photo shoot, we ask him to share his thoughts on shosa. "It's more about the automaticity of movement, I guess. I've only been doing this for twenty years and still have to consciously think about what I do. Once you stop thinking, you've become a master. In a way, it's similar to a craftsman who repeats the same routine movement until he reaches a level of mastery. We do the same thing. Our attitude and concentration are comparable. But we make movements instead of products. I suppose we practice the shosa of the sword."

"I've only been doing this for twenty years and still have to consciously think about what I do. Once you stop thinking, you've become a master."

Fascinated by the dojo, we ask Kyoso for another meeting for a photo in the dojo this time. Kyoso demonstrates his iaijutsu, slicing the air in front of him with a six-hundred-year-old sharp shinken. Afterwards, Kyoso meticulously cleans his sword with oil while maintaining a straight posture. It is a moment of some intimacy. Finally, we request a photo with the current head of the family, 87-year-old *soke* Yasusada Iizasa. He agrees, and then something happens that neither the photographer nor I can explain. As the old man kneels down and bows in front of the altar, something in the atmosphere seems to shift. "It's like a movie", the photographer says as he shoots photo after photo. The movements of the old man seem perfectly natural and utterly simple, yet an aura lingers around him. As we walk out of the dojo, the photographer asks: "Did you see that?!" His face is flushed, and I notice that he is holding back tears. I feel goosebumps. The soke had an inexplicable, gripping presence. What we witnessed was an example of shosa in its purest form.

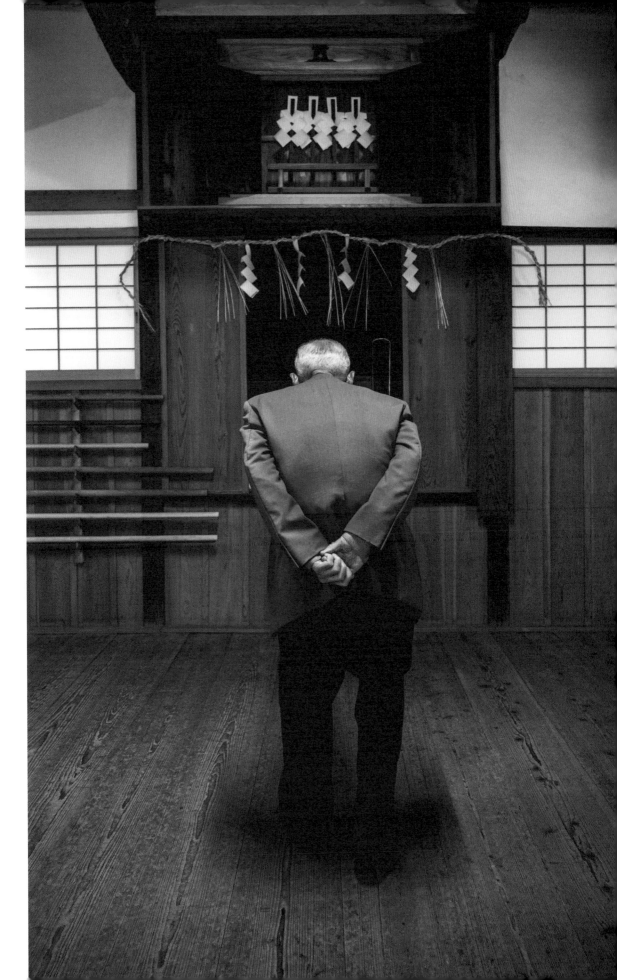

In constant admiration

Misato Sano
Wood sculptor
Matsushima

佐
野
美
里

Tohoku, the northeastern region of Honshu, the main island of Japan, is the country's lesser-known hinterland. In the 17th century, the famed haiku poet Matsuo Basho journeyed through its rugged and unknown terrain to write his world-renowned book, *Oku no Hosomichi*, which translates to "The Narrow Road to the Deep North" or "To the Interior". The word *oku* conveys depth, both literally and metaphorically. During his northern travels, Basho also visited a place called Matsushima. In fact, he was so overwhelmed by its beauty that he was left speechless, writing: "My pen strove in vain to equal this superb creation of divine artifice."*

For many centuries, Matsushima has been considered by some to be one of the three most scenic places (*Nihon sankei*) in Japan. The name reflects the town's charm, literally meaning 'pine tree island'. Matsushima is located in a bay of the Pacific Ocean containing over 260 small islands, most of them uninhabited and not much bigger than a large rock. The pine trees clutch these rocks with their roots like claws, weathering the forces of wind and water. In Japan, pine trees symbolise resilience and longevity. The pines of Matsushima are tested daily to prove that they are worthy of this symbolism.

When this coast was ravaged by the catastrophic earthquake and tsunami in 2011, which took nearly twenty thousand lives and caused the Fukushima nuclear meltdown, Matsushima survived relatively unscathed. Locals attribute this to the islands acting as natural wave breakers. On the nearest islet, just a bridge away from the mainland, stands Godaido, a simple wooden temple hall and – for lack of a better word – the town's mascot. It survived the tsunami without any noticeable damage. "Perhaps it was the protecting hand of Buddha", a resident once told me.

Today, the town welcomes more than a few busloads of tourists a day. They take boat tours to see the islands, visit the many temples, enjoy some excellent tuna sushi or grilled oysters at the local shops and take a stroll on the red bridge towards Fukuurajima, an island with beautiful vistas of the bay. Around 5 pm, the calm returns. This is the town's ebb and flood.

Further inland, Matsushima consists of fields and hills. There, I walk inside a shabby but charming rectangular building with metal wall cladding. Upon entering, a unique scent wafts towards me. "That's camphor," says Misato Sano, a young sculptor with an irresistible smile. "I work exclusively with this wood. Camphor mainly grows on the southern island of Kyushu, where the tree is revered for its height and strength." The scent adds to the beauty of the studio with its soft lighting, its set of perfect Japanese chisels lying on the table, its wooden dust and its many... dogs.

Sano dedicates her life to carving sculptures of canines with twisted yet amiable, rounded shapes and unfathomable grins. "The first one I made was a portrait of the family dog," she explains. "At art university, I was given an assignment to create a sculpture based on an object that was close to my heart. Without realising it, I made a version far larger than the dog itself. It took me by surprise. Is my love for this dog that immense?" The sculpture sparked a journey of self-exploration that continues to this day. "As a child, my parents were always working, and I felt quite lonely. Often, when I tried to talk to them, they would say they were too tired. Although I now understand that they merely wanted to ensure financial security for the family, their absence inspired negative thoughts. The family dog filled the emotional void."

Her second sculpture depicted someone else's dog; the third was a self-portrait. Since then, most of her sculptures represent her emotions. "I do what I wished my parents would have done: to look at me. As an outsider, I now observe myself and ask how I'm doing. My dogs are the result." You might say that Sano's work captures the narrow road to one's inner self. Art gave her a way to channel the storms that rage in her heart.

Although the idea is usually that an artist should relocate to a big city to absorb its art scene, Sano's introspective attitude resonates more with the quietness of rural Japan. "As a student, I was afraid of the big city, which is why I studied art at Tohoku University in Yamagata". This prefecture, with its capital of the same name, lies in the middle of mountainous Tohoku. "Big cities imply large crowds and a speedy life. Your personal space remains limited. I prefer a large room where I am free to start a dialogue with myself. In order to grow, I need space. Literally and figuratively speaking."

"I do what I wished my parents would have done: to look at me. As an outsider, I now observe myself and ask how I'm doing. My dogs are the result."

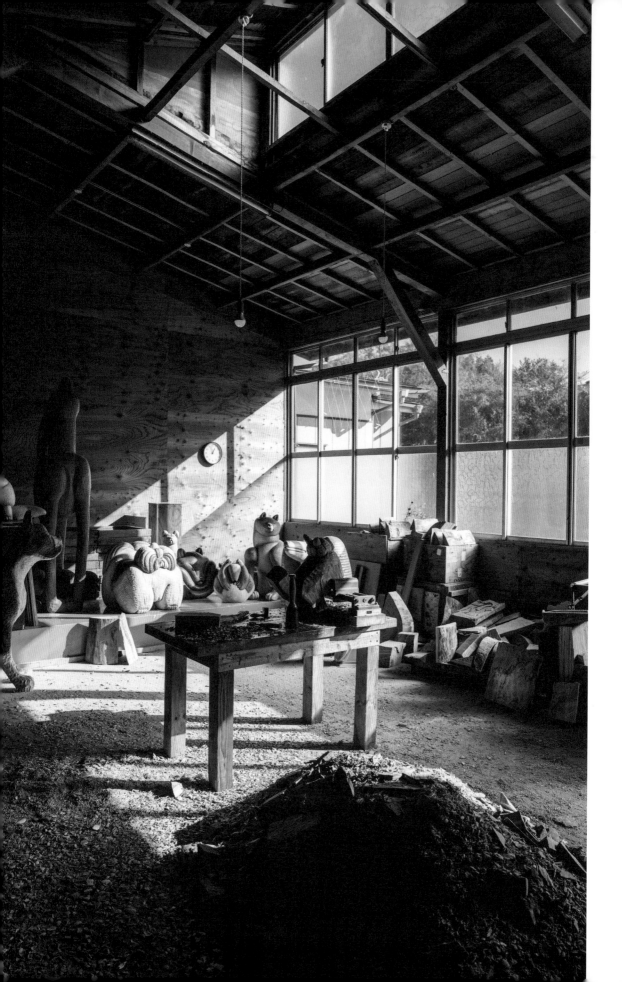

The fact that her dogs often look happy is merely due to the fact Sano feels blessed by the coincidental turns her life took. "For instance, four years ago, I met my American girlfriend Adriana, who was travelling around Japan, at an exhibition in Tokyo. I am still touched by the coincidence of it. I feel that so many lucky moments have come my way." Another moment of luck was finding this carpenter's studio where she now works and lives. "Although my hometown Tagajo (a suburb near Sendai, the capital of Tohoku) isn't very exciting, I had to return there after my studies. But I needed a workspace where my hammering wouldn't bother anyone. For six years, I rented small rooms here and there for a few months, sometimes nothing more than a small shack on a farm. It was far from ideal. Finally, about eight years ago, the father of a friend-of-a-friend, who was a carpenter on the verge of retirement, offered this workshop for a very reasonable rent. With the help of friends and family, I renovated the place in four months. Even my grandmother assisted by rolling *onigiri* (rice balls) for the hungry helpers. It was a wonderful experience. The carpenter, who was initially sad about his forced retirement due to health issues, felt alive again because of our enthusiasm and decided to help out. His family still says we didn't just renovate the building, but also his heart."

Sano steals your heart the minute you meet her; that's just the kind of person she is. She will invite you to have lunch at her 'parents' across the street, the landlord and his wife whom she's grown fond of and visits daily. I ask her what people think of her work in Japan, considering it is very much a cat country. Cats are everywhere in pop culture, and when you are out with a Japanese person, and you spot a cat, you are likely to experience an awkward moment of tremendous admiration. Cats also symbolise luck. The most obvious example is the *maneki-neko*, waving its mechanic paw at restaurant entrances.

"But long before that, dogs were more important," Sano explains. "As early as the Jomon period (a prehistoric era that began thirteen to fifteen thousand years ago), dogs were used for hunting and protection. To be honest, I once tried to sculpt a cat. It just didn't work. All cats virtually look the same. Dogs, on the other hand, are perfect for expressing emotions. There are so many breeds with completely different appearances." The pug looks like a comedian, the terrier like a feisty soldier, and the Bouvier des Flandres is a loveable goofball. You can find every human trait in dogs.

Though Sano's dogs express a range of feelings, they are all distinctively chunky and round. "Like a mother's body," she explains. "Curves like hips, thighs or a mother's arm cradling a baby all inspire me. Visually, curves offer a sense of safety." The eyes are kept small to avoid an all too *kawaii* (cute) image.

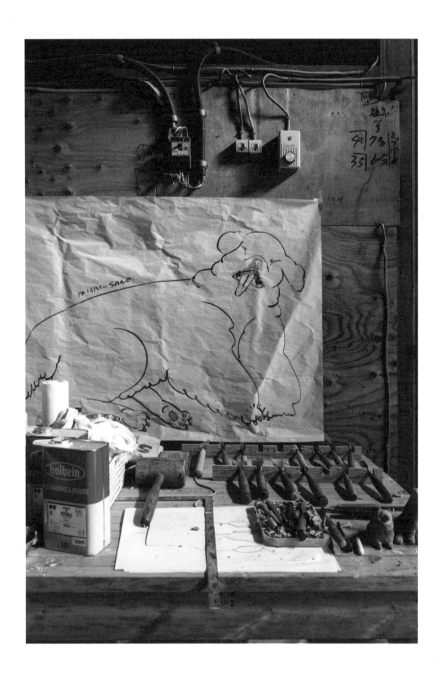

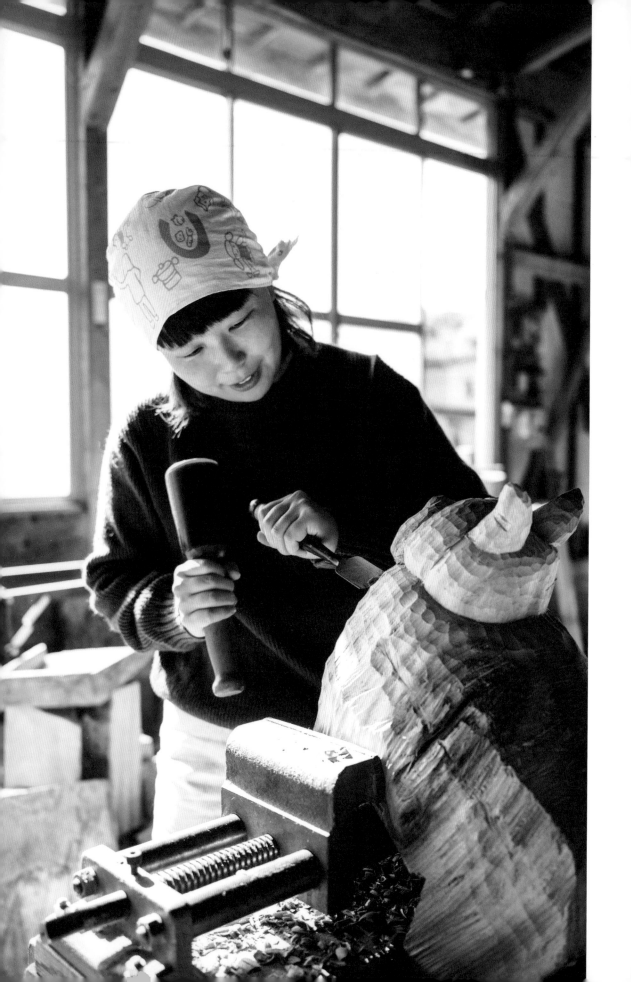

Every sculpture is patiently carved with nothing more than a hammer and a chisel. "It's hard work, but I find it meditative," Sano says. I ask her if the repetitive moment of hammering is related to shosa. "Every time I strike the chisel with my hammer, I think of the wood with a feeling of love. For me, shosa implies a deep respect for the material and the connection between my spirit and the wood. When I follow a grain, I think: 'I want to bring out your beauty.' It's almost like conversing with the wood."

Her deferential and respectful behaviour towards the material takes on an almost spiritual dimension. "I now put the wood on the same level as me, and not above me, in contrast to my student days when I felt I was beneath the wood. I became paralysed and unable to work. Who was I to reshape the already beautiful form of this material? Now, we live side by side, the wood and I, as equals. The time and concentration I give the wood, that's the real shosa for me."

In and around Matsushima, there are thus stores where you will be greeted by a grinning dog rather than a waving cat, like in Le Roman, a cafe on a nearby hill with a striking view of the islands. Sano's dogs have become the dogs of Matsushima – the bay's huggable gatekeepers.

From The Narrow Road to the Deep North by Matsuo Basho, translated by Nobuyuki Yuasa. First published by Penguin in 1966

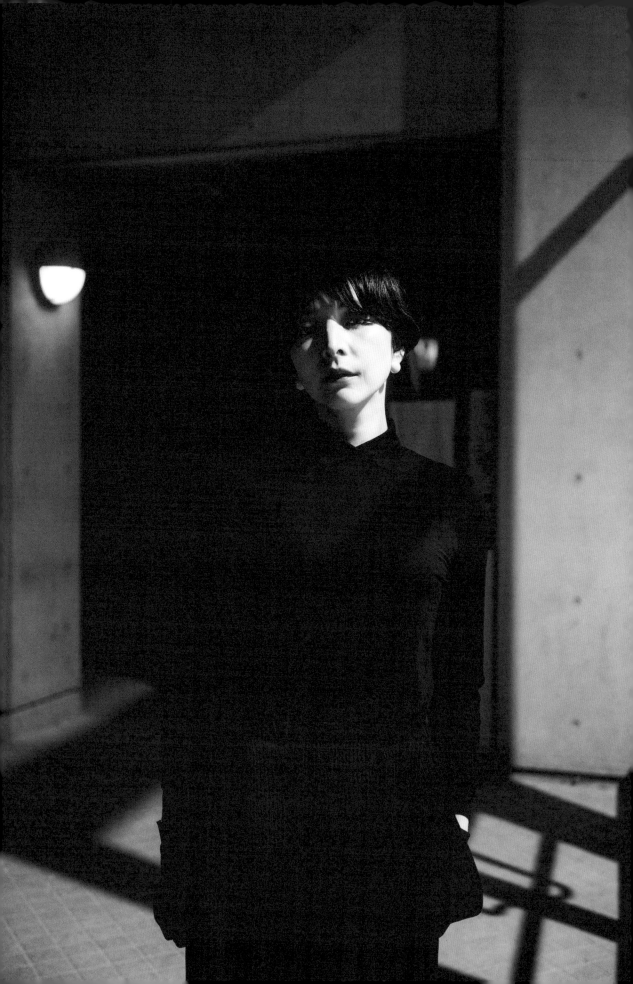

The shosa of earthquakes

Saori Hala
Choreographer
Tokyo

ハ
ラ
サ
オ
リ

I met Saori Hala by accident through a fashion designer named Kota Gushiken, whom I was supposed to interview for a different job. As we chatted in his small studio among the clutter and wool yarn in a nondescript building in Shibuya, I mentioned that I was researching shosa. He responded with an anecdote about a dance performance of a friend and choreographer he recently attended. "After the show, I approached her and said, 'Your shosa was beautiful'", he said. "She nodded and thanked me, which made me feel she understood what I meant."

While waiting for Hala, I sit on the upper floor of a *kissaten* near Gotanda Station in Tokyo, gazing out of the window. A kissaten is a retro coffee shop, often styled after Western cafes from the 1950s, 60s and 70s, the decades in which these small shops became popular in Japan. They played classical music and jazz in these places in response to people's interest in Western music. Since the 1980s, they have gradually shuttered as large coffee chains have swamped the market. Today, the *kissa*, as they are usually called, still exude nostalgia and are sought out for their pleasant atmosphere.

In the dreary Tokyo weather, I observe the daily theatre of a busy intersection in the big city. People stop, wait for the traffic lights and then cross. Over and over again. At a certain point, I notice a peculiar figure among the sea of pedestrians. The figure has a certain dignity about her, although it never feels boastful. Among the weary salarymen and women, she almost seems otherworldly. I realise it is Hala.

"Kota said that my shosa was especially lovely as I walked off the stage," Hala explains with a slight grin as she sits down opposite me. "This really gave me a fresh perspective on my movements. No one had ever referred to my shosa before." I believe Kota saw what I saw from the window earlier.

Saori Hala — Choreographer

Although Hala looks different from the Tokyoites on the street, she was born and raised here. "But the city has many faces," she says. "I grew up in a rather quiet ward called Setagaya, in the southwest of the city. It is near the Tama River, and there is a green valley called Todoroki. My childhood memories are of playing by the water and enjoying nature. As a teenager, I would often take off with friends to busy Shibuya. It's only thirthy minutes by train."

On 11 March 2011, the Tohoku Earthquake claimed over twenty thousand lives and triggered a massive tsunami. In Fukushima, a prefecture north of Tokyo, the nuclear power plant suffered irreparable damage, forever etching the prefecture's name in international memory as a toxic Chornobyl. Although damage in Tokyo was relatively limited, Hala was shaken. "The government lied about the safety of the nuclear power plant and just kept on lying and manipulating as time went on," she says. "They explicitly stated that food from Fukushima wasn't harmful to our health. There were even commercials with Japanese celebrities smiling as they bit into apples that had been grown in Fukushima. That kind of propaganda divided society." But it was not just the government that eroded her trust. "I was studying design and art and was about to graduate. I started noticing an attitude in people that they didn't care about these disciplines. There were also no investments in art or design whatsoever. In short, I lost faith in both the government and the people."

And so, Hala decided to leave her country and her field of study. "I wanted to pursue an art form that I could practice on my own, that would allow me to set society aside. That's how I turned to dance". She chose to move to Germany partly because of its history of (fascist) propaganda. "I wondered how people in such a country would engage in self-reflection – which, in hindsight, wasn't as profound as I expected. I enrolled in the Bauhaus University in Weimar. No one spoke English, so I began studying German. On weekends, I travelled to Berlin and participated in dance workshops. After three months, I decided to move there."

Although Hala lived in Berlin for a decade, her work often referenced Japan. Earthquakes became one of her central themes. "It all started from the connection I established between dance and the theories I learned when studying design," Hala says. "I analysed how objects and the immediate surroundings influence our movements; for example, how a particular chair determines how you sit. I realised how little we actually decide for ourselves. While the dance world often focuses on expression – movement stemming from within – I wanted to create a choreography that originated from external forces". A choreography that focused on how the body moves in response to the shaking of the ground. "There are many tragic stories about earthquakes. I want to focus on the movements: the jolts, the sways, the pushes."

Hala is also fascinated by the prescribed movements during earthquakes, such as emergency drills. "From a young age, you learn at school what to do during an earthquake. Crawl under a table and remember to protect your head. Wait until the shaking stops. Form two lines, one for boys and one for girls, and walk to the designated evacuation point. Keep your slippers on, and don't put on your shoes (Japanese take off their shoes in class and office, just like they do at home). While standing in line, we must all shout: '*Osanai, kakenai, shabenai, modoranai*!' No pushing, no running, no talking, no turning back. It is an incantation designed to remind you not to panic. Every year on September 1, we practice this drill. It's the anniversary of the 1923 Great Kanto Earthquake that devastated Tokyo."

Earthquakes are a persistent reality in Japan. "Every three months, you feel a small quake. But in 2011, I thought: this is it, I'm going to die. The shaking lasted more than a minute. This may seem short, but it feels like an eternity when you're experiencing it. I remember it well. I was in my room, hidden underneath the table, and I became worried about my laptop. It was on the table, and I ended up holding onto it with one hand. It's an expensive piece of equipment", she laughs.

In a video of her performance called P Wave, I see how Hala translates all her experiences and ideas into contemporary dance. There is a scene where the dancers move through the space in a state of calm and serene alertness. "Calmness or rather passivity is important in an emergency", Hala explains. However, this sense of passivity is not limited to disasters. By researching earthquakes, she came to the conclusion that Japanese people, and even Asians in general, adopt a more passive attitude than Westerners in their daily lives.

This is already apparent in their posture. In general, Japanese people stand, walk, and move in a slightly different way than Westerners, seemingly taking up less space, keeping their arms closer to their body, and holding their back straighter. "We also tend to avoid direct eye contact and look from the corners of our eyes." This rather passive and reticent attitude seems to be embedded in traditional Japanese culture. Think of a *shamisen* performance (the Japanse lute) where musicians sit perfectly still, their expressions blank, moving only the muscles in their hands. Or *Noh* theatre with its slow, minimalist movements and speech. Or the tea ceremony, a celebration of simple, calm gestures.

Although a Westerner in Japan might immediately notice this difference in posture and attitude, they might find it difficult to put it into words. When Hala says passivity, everything suddenly becomes clear. "Passivity might have a negative connotation in the West, but it's a key element of the Japanese attitude."

This passivity could well be an essential breeding ground for shosa, in which calmness, serenity and elegance are revered.

"A dystopian shosa is spreading in Tokyo. Many people, low on energy, are simply dragging themselves through life."

For Hala, shosa is a rather formal concept that she associates with traditional culture. "For me personally, it implies an action with a clear purpose. When this is the case, the movement becomes naturally beautiful. As a choreographer, I always ask myself: does this movement have a purpose? Of course, there are dancers who focus on intuitive movements to express their inner selves. This has been the foundation of modern dance since the very beginning, and that's fine. But I want to create a choreography that doesn't start from the inside but from the outside. As a dancer, I don't initiate; I respond. I focus on non-anthropocentrism – not putting the human being at the centre." It sounds almost like a meditative stance.

"Contemporary dance is heavily rooted in Western traditions like ballet or modern dance. I want to give it Asian roots and link it to Asian ways of being." This means starting from the posture of a Japanese person rather than that of a Westerner. Still, Hala admits that the average Tokyoite's posture leaves much to be desired. "Tokyo is dying. The city's economic, political, and cultural strength is declining. Education, research, and the arts are no longer a priority. You can see it in people's demeanour. A dystopian shosa is spreading here. The shosa of traditional Japanese culture is far removed from today's reality. Many people, low on energy, are simply dragging themselves through life. That's the real shosa of many Japanese citizens today."

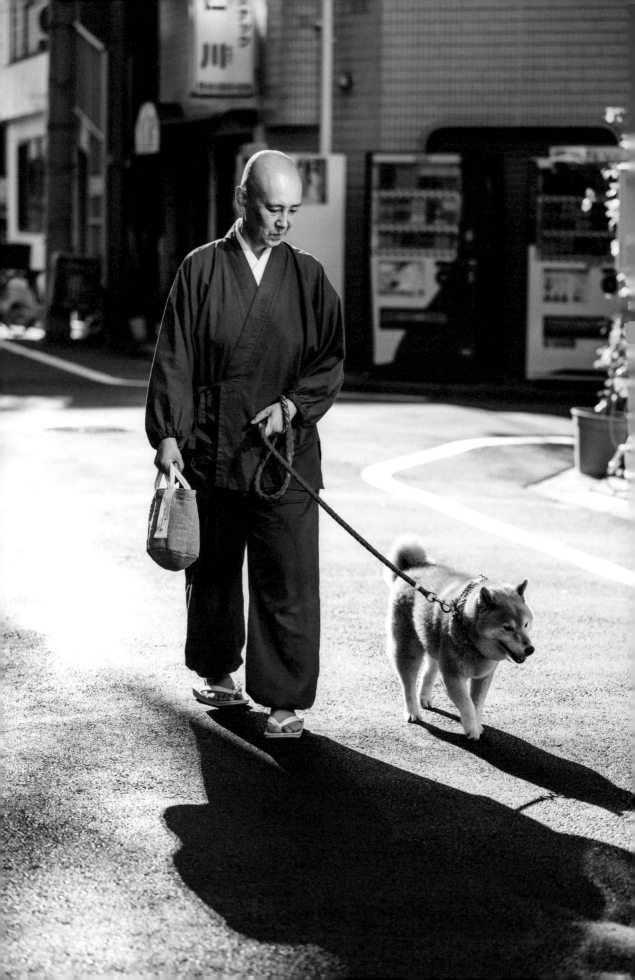

Life is shosa, shosa is life

Yuko Wakayama Yamada
Soto Zen monk
Tokyo

山
田
若
山
悠
光

"Shosa is of great importance in Zen Buddhism. In fact, we make no distinction between the way of moving and the actual experience of Buddhism. Your attitude and behaviour are equivalent to the principles of Zen Buddhism itself. You could say that shosa is Buddhism... In other words, you're in the right place."

I am sitting at a large conference table in front of a whiteboard. The room is wide, and the floor is covered with a bright green carpet. This is the study hall of Shokaku-ji, a temple near Nishi-Nippori Station in Arakawa, a northeastern neighbourhood of Tokyo, just behind Yanaka, which is known for its nostalgic vibe. The temple, like the neighbourhood itself, has no particularly remarkable appearance and is not indicated on any tourist map. Shokaku-Ji is perfectly inconspicuous.

The person who runs the temple, however, is quite the opposite. Her name is Yuko Yamada, and she is a monk in Soto Zen, one of the biggest Zen sects in Japan. While women can become Zen monks, there are noticeably fewer women than men. Apart from being a woman, Yuko Yamada's journey has been quite peculiar. "Even though my parents were followers of Soto Zen, I first became a Franciscan nun," she says. "I was at university, far from my parents and in a completely new environment, living all alone. At the time, my mind was somewhat troubled. When my best friend invited me to go to church, I was struck by the beauty of the experience: the light through the stained glass, the wonderful hymns... It felt like a dream world to me. From then on, I went to church every Sunday and sang in the choir."

Eight years later, she decided to enter a remote monastery in the mountains of Gunma Prefecture, north of Tokyo. "I found it to be a beautiful world and loved wearing the nun's habit. Three years later, a pastor visited to talk about other religions. Through him, I learned about *zazen* (Zen meditation), and something clicked in my mind. I felt it was closer to my roots and wanted to try it. Seeing that this wasn't possible within the monastery, I had to leave. I felt: it's now or never."

207

Yuko Wakayama Yamada — Soto Zen monk

Yamada left the monastery. "There I stood outside the gate, my sole possessions being the clothes I wore when I entered the monastery and a small amount of money – the entry fee I had paid three years before. I called a taxi and asked: 'Take me to a temple'. He asked which one. I thought it didn't matter", *(laughs)*. The closest temple turned out to be one of the Soto Zen schools. Coincidentally, Aoyama Roshi, a renowned female Zen monk, was giving a lecture there at the time. "She recommended that I go to Senmon Nisodo in Aichi Prefecture, a training school exclusively for aspiring female monks."

"Because I had already lived in a monastery for three years, I honestly thought it would be easy," Yamada says, "but in the end, it took me five and a half years to become a monk. The daily life of a nun and a Zen monk are quite similar, so discipline wasn't an issue. I will explain the main difference I experienced using the symbols of both religions. In Catholicism, the white lily is the symbol of faith. It is white, pure, and blooms toward God. We confess daily to cleanse ourselves from guilt and remain immaculate. In Buddhism, the lotus flower is an important symbol. This flower is rooted in mud and blooms in all directions. In Zen, there's no God in heaven. Your own nature is divine, and it must bloom towards everything and everybody. The mistakes you make in life, symbolised by the mud, serve as nourishment for the flower."

Although countless books have been written about the vast teachings of Zen Buddhism, the essence of this philosophy is not complicated. In Zen, it is said that all living things contain the 'Buddha nature', meaning divinity. Instead of a God in heaven, everything on earth is sacred and equal, from a human being to the smallest grain of rice. It is only when you acknowledge this that you can live in harmony with all other beings in the world. However, most of us suffer from imbalance. Fuelled by desire, our ego tends to value things unequally. By setting aside our ego and treating everything equal again, we can regain harmony and peace.

The main practice for achieving this state is zazen or meditation. In Zen Buddhism, there are two major schools: Soto and Rinzai. The latter uses *koan* during meditation. These are paradoxical statements from old priests that, when contemplated, open the mind. "In Soto Zen, zazen does not involve meditation", Yamada explains. "We focus on nothing. Zazen implies just sitting and observing without rationalising. For instance, I clap my hands, you hear a sound. That sound is a fact. But people tend to start thinking about the fact, attaching thoughts and feelings to it. Zazen is about registering the facts and nothing more." In other words, it is a pure and objective observation and a complete shutting down of the thinking process.

Zen is often framed as a form of spirituality, but in reality, it is a highly rational philosophy: a purely phenomenological way of living. People who put themselves at the centre of their life might actually be more spiritually inclined. For what is an ego? A vague, immaterial ghost that controls the body and the mind without you being aware of it. An ego leans more toward a dogmatic god than Zen does.

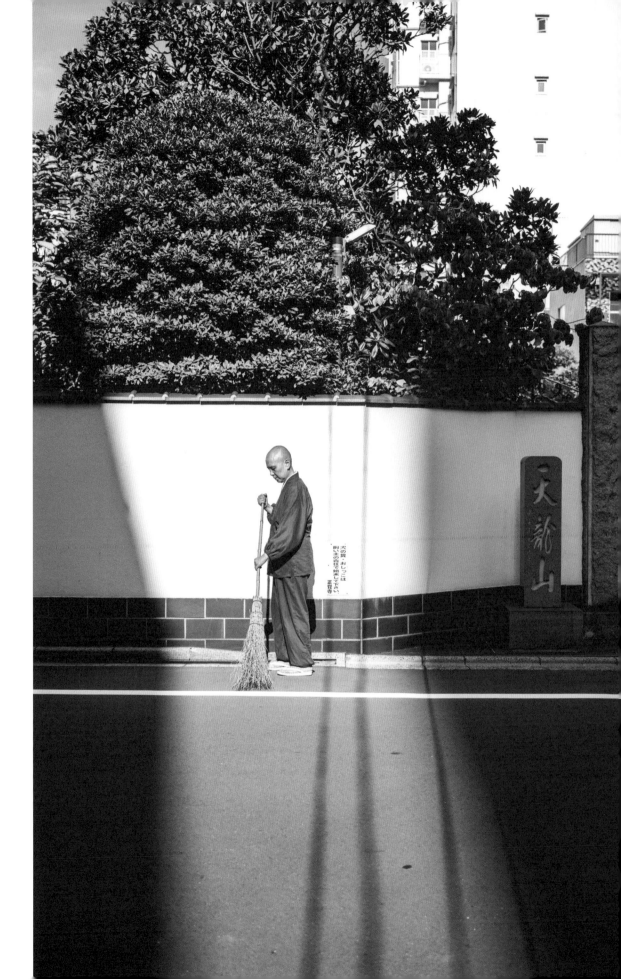

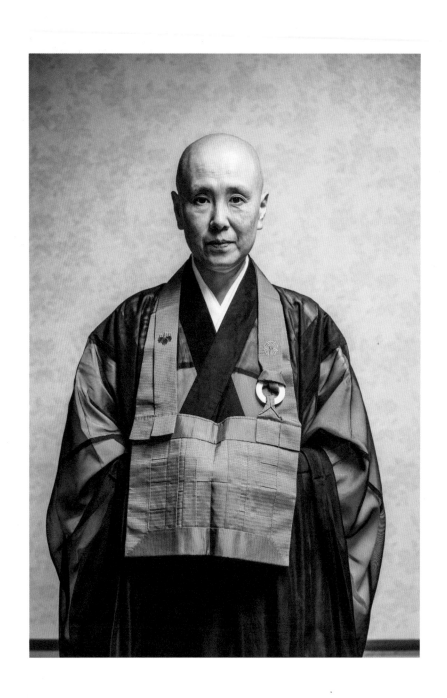

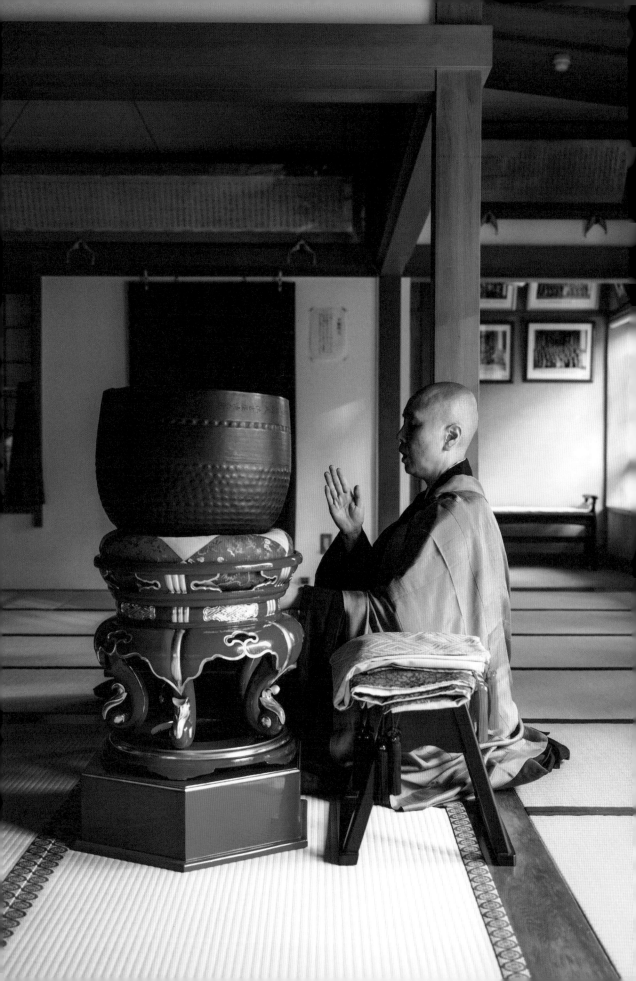

"It's the daily task of the Zen student in the morning to remove the rice from its husk, grain by grain. It's a tough chore, but it teaches you to notice that every grain of rice is unique."

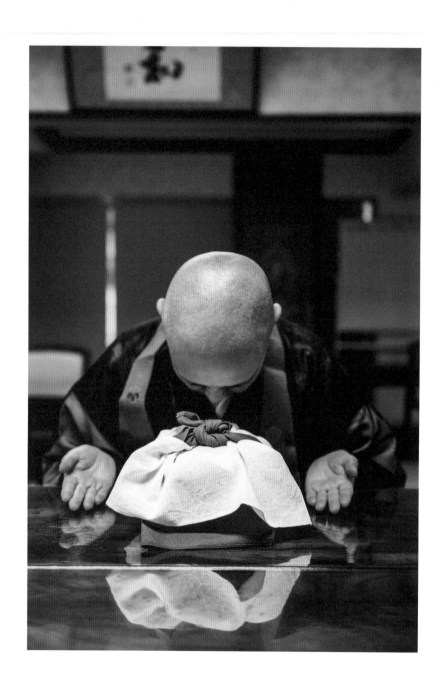

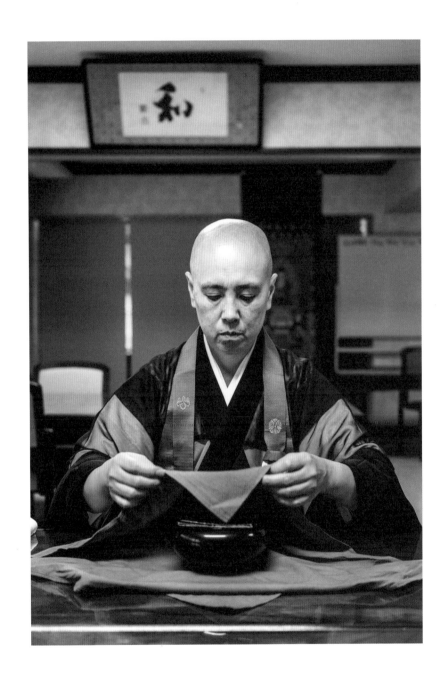

Zen and shosa, according to Yamada, are strongly connected. "The way you move and behave is who you are," she states. "Your actions are the expression of your inner self. So shosa is the result of your mind". A harmonious inside leads to a balanced shosa. But does it work the other way around? "You get the point", she says. "If you straighten your back, you also straighten your will. The ego bends the body, and we train to eliminate our ego. The goal is to become nothing. In doing so, you become part of the earth and its harmony."

In Soto Zen training, life revolves almost entirely around perfecting the right shosa. "You live according to a strict schedule and set of rules. Every movement you make must be done in a very specific way. Every day, you wake up at 4 am to practice zazen, and at 9 pm, the lights go out. Even eating is done in a specific manner, using specific utensils." She shows her set of three black bowls for rice, miso soup, and vegetables, which are stacked and wrapped in blue cloth. Yamada demonstrates how to carefully unwrap the cloth, separate the bowls to eat and clean the bowls afterwards with hot water, drying the bowls and rewrapping everything. Her movements during this tiny ritual are of immense simplicity and beauty.

"At first, you feel very conflicted because of this rigid schedule, but gradually, you come to accept it." These conflicts are essentially problems of the ego, meaning you have preferences, likes and dislikes. "The rules are designed so you can live in perfect harmony with your environment. Shosa is all about not breaking that harmony." As a tea master says "Move in such a way so as not to disturb the harmony." It is no surprise that the tea ceremony was created by Zen monks. For Zen monks, however, shosa goes beyond the tea room. Their tea room is the universe. "We believe that all life possesses Buddha nature, even the smallest drop of water. For us, shosa means showing respect to everything that possesses this Buddha nature."

Everything is sacred and deserves to be approached with reverence. "In principle, we don't eat meat but we are aware that even rice has Buddha nature. Therefore, it's the daily task of the Zen student in the morning to remove the rice we receive from its husk, grain by grain. It's a tough chore, but it teaches you to notice that every grain of rice is unique. When you eat the rice later on, you realise that you are taking the life of every single grain."

Dogen Zenji, the founder of Soto Zen Buddhism, recorded many of these rules for posterity in the thirteenth century. "In his book *Shobo Genzo*, he wrote about how to cook, how to wash your face and even how to go to the toilet." Through zazen, the monks learn that all of life is essentially one long zazen session. Daily tasks such as cleaning are just as important as meditation itself and are done in a specific way: with a wrung-out cloth, on your knees, scrubbing the floor as you move the cloth up and down over and over again. "During my training, I observed a seventy-year-old monk cleaning. Her spirit was so pure that it moved me. When she wrung out the cloth, I burst into tears." Beauty isn't about form but about the intention. Everything that is done with sincerity, even if you are just cleaning the floor, is of the most incredible beauty. If you remember one thing, let it be this.

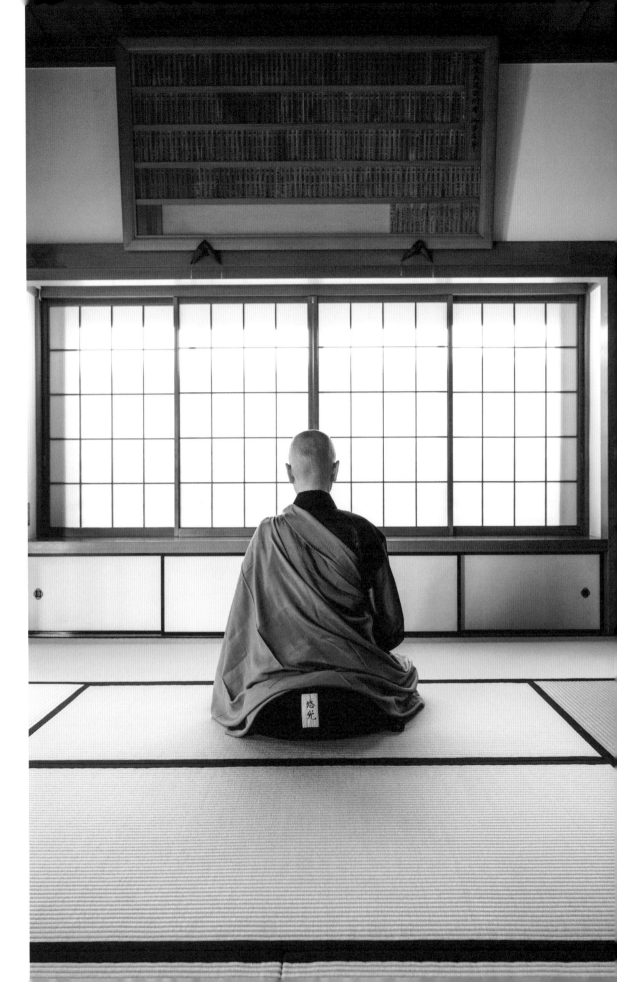

About the author

Ringo Gomez is a freelance design journalist based in Antwerp, Belgium with a long-lasting fascination for Japan and the country's traditional crafts. He has written multiple articles on Japan for the Belgian newspaper *De Standaard* and other media, and covers experimental design in Europe.

About the photographer

Rob Walbers is a Belgian photographer based in Tokyo for over a decade. His diverse body of work ranges from fashion to documentary photography. Passionate about exploring marginalised communities, Rob is renowned for capturing his subjects in black and white. In this book, he returns to color photography, his first love, rekindling a creative journey that began at the start of his career.

Colophon

Shosa
Meditations in Japanese handwork

Words — Ringo Gomez
Photography — Rob Walbers
Interpreting — Takaharu Saito — oshinsha.jp
Communication assistance — Ulala Tanaka
Final editing — Sandy Logan
Graphic design — Inge Rylant

D/2025/12.005/2
ISBN 9789460583803
NUR 450, 521

© 2025, Luster Publishing, Antwerp
lusterpublishing.com
info@lusterpublishing.com

Subscribe to our newsletter for new book alerts
and a look behind the scenes:

Printed in Italy by Printer Trento.

We want to thank Takaharu Saito for his never-ending support. He was our interpreter during the interviews and was always there. This book is as much his as it is ours. Furthermore, we would like to thank Ulala Tanaka for her assistance, as well as Tokiwa Mori and Shinichi Chiba for their support. And finally, we are indebted to all the interviewees for their willingness and time.